COLNE
THROUGH TIME
Geoff R. Crambie
& Colin Bean

AMBERLEY PUBLISHING

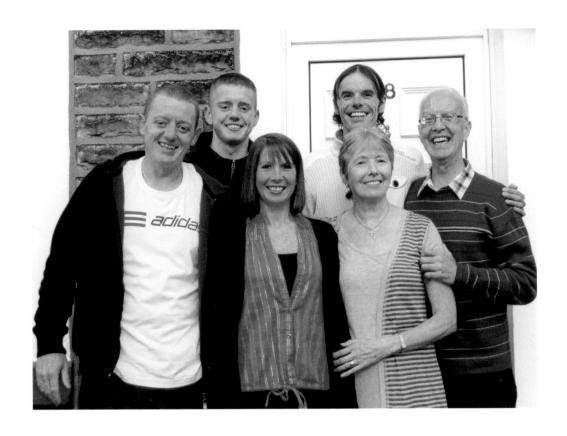

This, my ninth book, is dedicated with love to my dear family:
Ruth, Shaun, Janette, Darren and Nathan.
September 2011

First published 2011

Amberley Publishing
The Hill, Stroud
Gloucestershire, GL5 4EP

www.amberley-books.com

Copyright © Geoff R. Crambie & Colin Bean, 2011

The right of Geoff R. Crambie & Colin Bean to be
identified as the Authors of this work has been
asserted in accordance with the Copyrights, Designs
and Patents Act 1988.

ISBN 978 1 4456 0309 4

British Library Cataloguing in Publication Data.
A catalogue record for this book is available from
the British Library.

Typeset in 9.5pt on 12pt Celeste.
Typesetting by Amberley Publishing.
Printed in the UK.

Introduction

First and foremost may I say on behalf of Colin and myself how proud we are to be telling the story of our town for the renowned Amberley *Through Time* series. The changes to Colne during our lifetimes have been phenomenal and in the pages of this book we hope to have captured how much those changes through time have been recorded in both words and pictures. For myself, I'm a truly fortunate man, as a young boy with my street pals Malcolm Graham and Allan Lister I've run up and down our historic Cloth Hall's thirty-two entrance steps many times. I've had tea with my school pal Malcolm Mcleod at his palatial home, the magnificent Alkincoates Hall. On a hot summer's day I've been bird's nesting inside the opulent Emmott Hall with my great friend Mick Crabtree, and I've looked round the 650-year-old crofter's cottage on Nineveh Street with my good friend Stanley Singleton. A day later it was gone, just as every one of these irreplaceable Colne buildings have too. The malady of the second half of the twentieth century, 'civic vandalism' has robbed our grandchildren and their children of ever seeing these and so many more of our town's historic places. What little remains must be looked after for those who follow. Through Colin's transcendent photographs and my perspicacious writing may you now be taken on a journey as we entertain conjecture of time.

Geoff R. Crambie
Colin Bean
Colne, August 2011

Nineveh Street's 650-year-old crofter's cottage, demolished in 1974.

A Poem by Our Town's Celebrated Poetess Renée P. Blackburn

A postcard from Colne, it's a Lancashire town,
It stands on a hill, it's a place of renown.
So many attractions in harmony blend,
A tourist location we're proud to commend

We've cruised the canal and we sailed Burwains Lake,
More visits to places of note we will make.
We've climbed up the hills and admired the view,
We've been to the Muni and Hippodrome too.

The largest of flagstones outside our town hall,
Our Sutherland Street is the steepest of all.
Our fine Parish Church and our old Market Cross,
The Primet Hill viaduct arching across

Our famous wheeled stocks from an earlier date,
Historical places which still fascinate.
Our town's quite unique and its assets we share,
Our rural surroundings beyond all compare.

Our town is so ancient of which we are proud.
With fine countryside we're so richly endowed.
My hometown is Colne and it's in the North West,
It's here I was born, it's the place I love best.

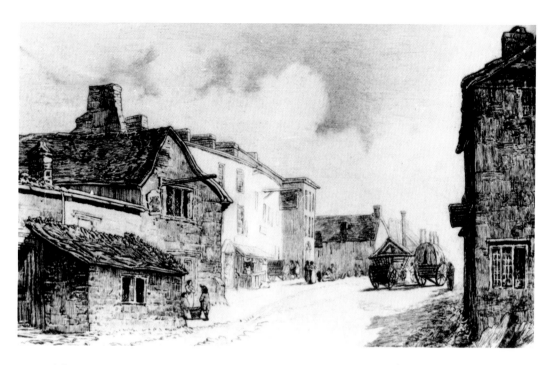

Eighteenth-Century Colne

Here we see one of the earliest representations of Bonnie Colne up on the hill. This is the town in around 1780 with the ancient market cross at the junction of Colne Lane and Windy Bank. The only building to be seen on both pictures is the Hole in the Wall Inn in the centre, having stood at No. 8 Market Street since 1706. Stand on the step of the public house, now named the Craic'I'th Wall Inn, and you are 632 feet above sea level.

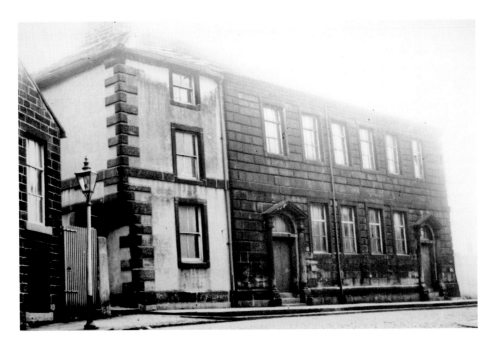

The Wesleyan Chapel

The aesthetic Georgian Wesleyan chapel seen here in the 1940s was a splendid building from all angles. The Revd John Wesley who visited Colne on several occasions was in town to preach at the newly erected chapel on Wednesday 11 June 1777. Due to the huge congregation present one of the galleries collapsed although miraculously no lives were lost. The chapel was sadly demolished in the early 1960s and here on Chapel Fold I point out the original 1777 stone step.

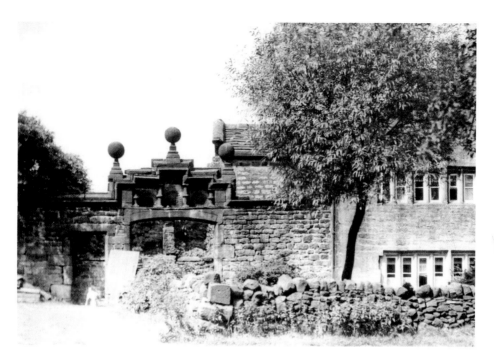

Hobstones

This is the ancient manor house of Hobstones, built in 1700 with its curious gateway being added four years later in 1704 as its datestone records. Hob was the Saxon word for dancing elf or fairy, and the name reflects the many strange happenings that have been recorded there. Hobstones was part of the Alkincoates estate, later becoming a farm and is happily still with us today. Here is my genial co-author, celebrated cameraman Colin with his own magnificent model of Hobstones.

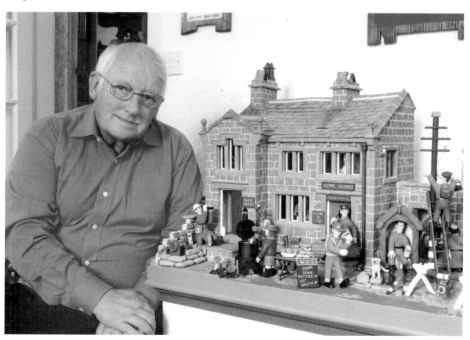

COLNE. C. M.

Music by FRANCIS DUCKWORTH, COLNE.

Je-su, the ve-ry thought of Thee

With sweetness fills my breast;

But sweet-er far Thy face to see, And in Thy pres - ence rest.

Our Parish Church

Here is Colne's oldest building, St Bartholomew's church, which is first recorded in the charter of 1122. On the north side of this transcendent place of worship are three mighty Norman pillars, which have stood proudly now for almost 900 years. Canon John Ross Macvicar MA was incumbent at the church from 1938 to 1955 and indeed presided over my christening in 1943. On the 1920s postcard note the original church clock on the east tower, which sadly has disappeared today.

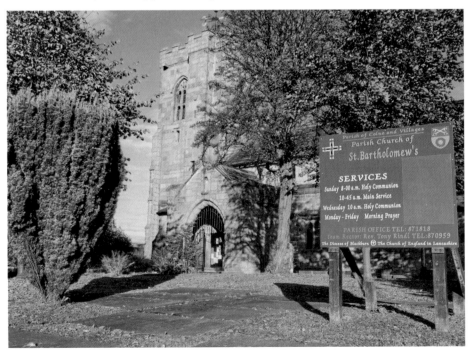

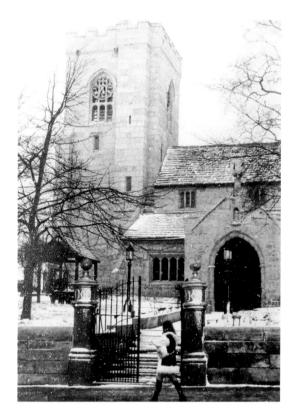

Winter and Spring

A snowy scene at our parish church in the early 1970s and almost forty years on spring arrives in a colourful church yard. The tower is sixty-two feet high and the view from the top is a stunning vista which takes in the whole of the town below. In the winter's day picture we see a later church clock on the south tower, today also removed and sadly not replaced. Also removed, on the left of our 1970s scene, are our town's unique three-seater, wheeled stocks, which now reside in the Colne public library.

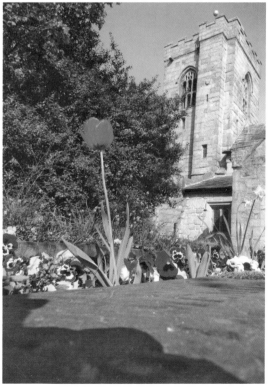

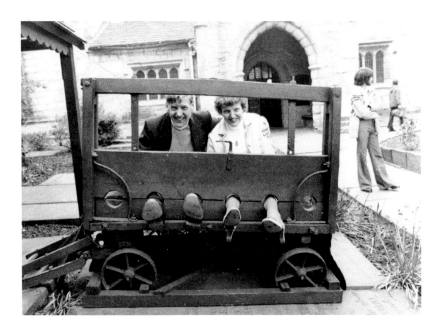

In the Stocks!

A wonderful picture from the summer of 1977. Here in the stocks are the Revd Noel Hawthorne MA and his dear wife Pat alongside. Noel was the rector of our parish church from 1970 to 1991 and was without a doubt our town's best-loved cleric of them all. The unique stocks were made by Hartley Smith *c.* 1834 and the last person put in them was William Wilkinson, for six hours in May 1858. Our colour photograph shows the stocks now *in situ* at our town's public library.

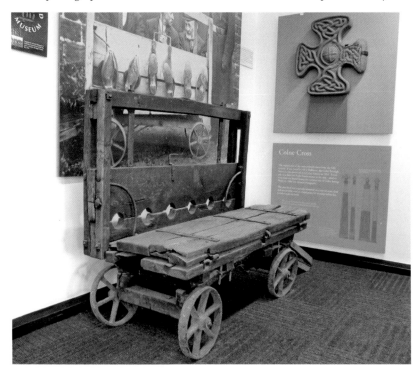

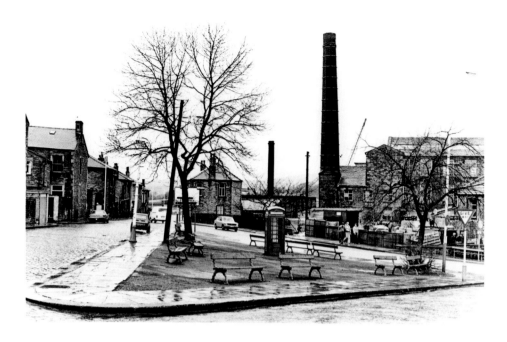

Hyde Park

This triangle of land is named Hyde Park after the newspaper entrepreneur Robert Hyde. On our 1977 wet-day picture is one of Colne's earliest mills. Vivary Mill is first mentioned as a fulling (woollen) mill in 1797. By the 1920s, cotton magnates Thomas Thornber and Nicholas England were the owners of the now round-the-clock cotton mill. Sadly demolished in 1985, the landmark mill chimney has gone from our colour picture. The lady seen here is Sharon Bradbury walking her dog Ben past our rare Edward VIII pillar box.

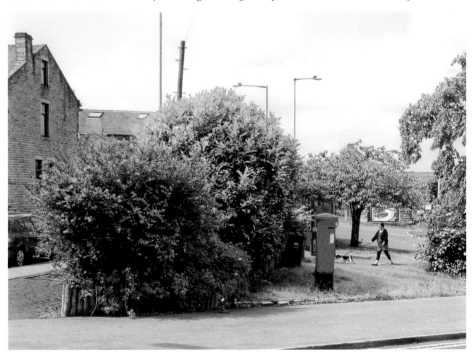

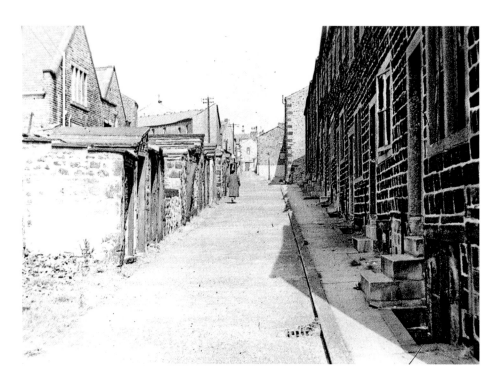

Nineveh Street

An excellent 1940s view of Colne's earliest recorded street. Nineveh Street's name derives from the ancient biblical capital of Assyria, which was destroyed by the Babylonians in 612 BC. Near the top of this long-standing street was a 650-year-old crofter's cottage. This historic cruck building was tragically bulldozed down in 1974 despite our eminent historian Wilfred Spencer's campaign to preserve it for future generations. Today Nineveh Street is a car park as seen in our present-day picture.

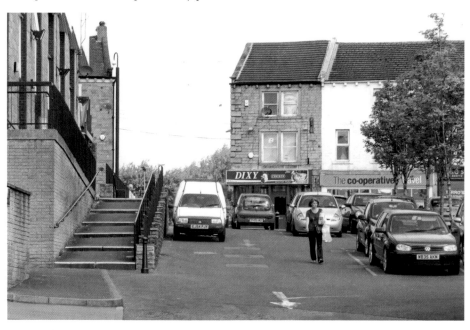

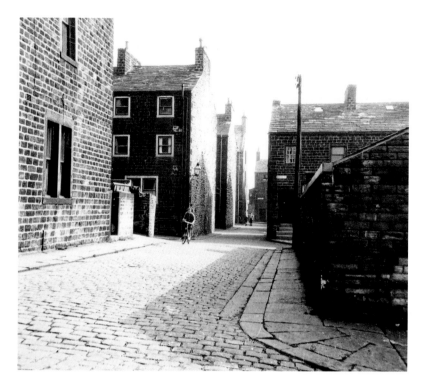

A Corner of Old Colne

A scene captured in the 1950s looking from west to east towards Nineveh Street and the old-world streets beyond. These timeless Colne dwellings were demolished between 1959 and 1963. They had evocative stone setts, gas lamps and huge stone roof slates. These were Nineveh Street, Parliament Street, Shackleton Street, Clayton Street, St John Street and Railway Street, all now gone forever. Colne bus station covers much of their ancient locality today.

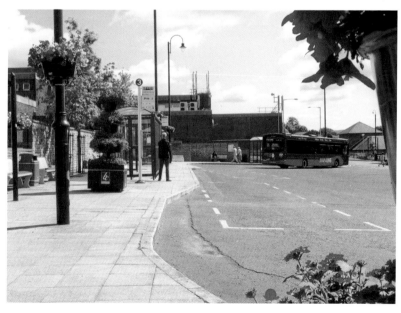

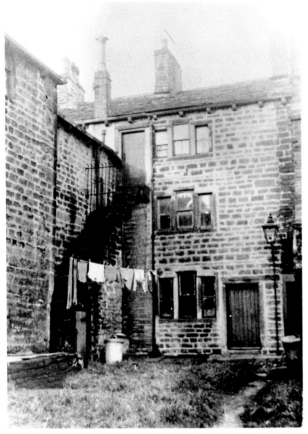

Bells Yard
Here, in 1954, we see the step-back-in-time Bells Yard, which housed some of the oldest handloom weavers' cottages in Colne. Bells Yard was named after the tradition of the occupants of the yard ringing handbells to sell their cloth. Just five years after this photograph, on 14 June 1959, demolition began down St John Street where this historic yard had stood for centuries. Today a brass band plays on the site which once echoed to clog irons on stone steps and the rattle of the weaver's loom and shuttle.

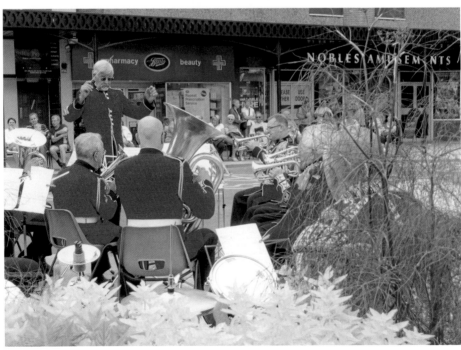

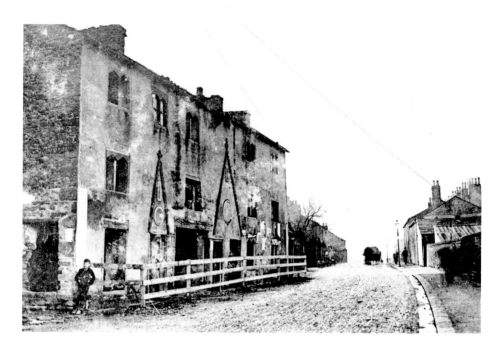

Naylor's House

A truly antiquated building is seen here on Keighley Road *c.* 1880 between the cemetery and Sagar Fold. This ornate-fronted structure was known as Naylor's House and dated back to the early 1600s. It was certainly in existence on 25 June 1644 when a battle took place between the Roundheads and Cavaliers on the nearby Kings' Field (now Colne Cemetery). Naylor's House was demolished not long after our rare photograph was taken and today traffic streams past this historic place.

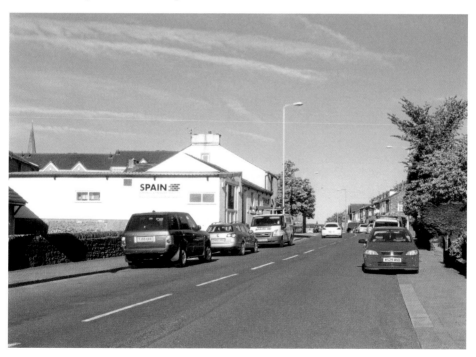

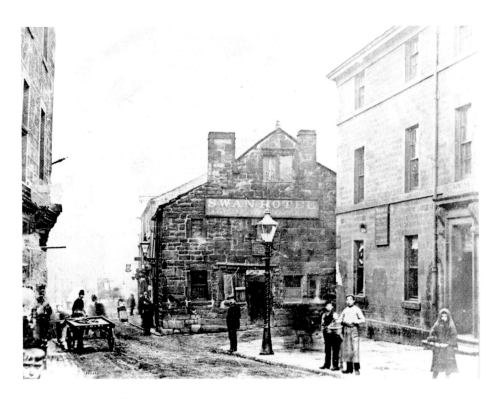

The Dog and Partridge

Colne in the 1870s and the ancient building bearing the sign 'Swan Hotel – Bait and Livery Stables' is none other than our town's very first named hostelry the Dog and Partridge Beer Shop. This Market Street public house dated back to 1611 and next door on the right is the Swan Hotel, built in the 1790s. In 1896 the Dog and Partridge (also known as Pinnacle Hall) was bulldozed down and is today the site of Colne market hall, while Altham's Travel is where the Swan Hotel stood.

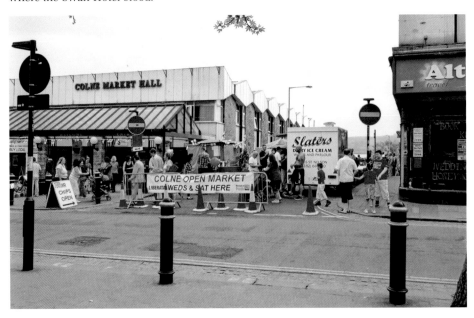

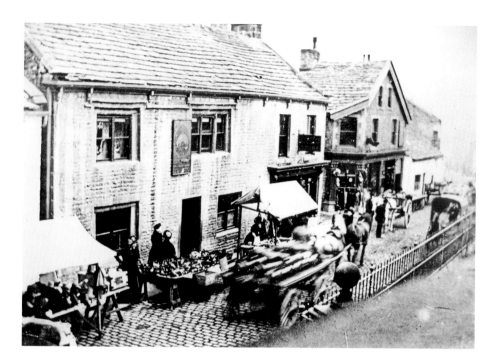

The Fleece

Church Street *c.* 1880 and here on a busy market day we can see the Fleece Inn on the left, which was built in the year 1665. Named after our local woollen industry, the Fleece was during the 1820s run by John Heap who was also the Sexton of the parish church. Further along far right is the White Horse Inn, which was demolished in 1886. The Fleece Inn lasted until 1905 and was replaced by a new, grandiose hostelry which lasted just fifty years. New buildings now stand today in its place,

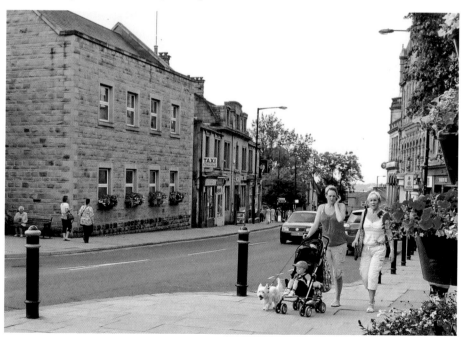

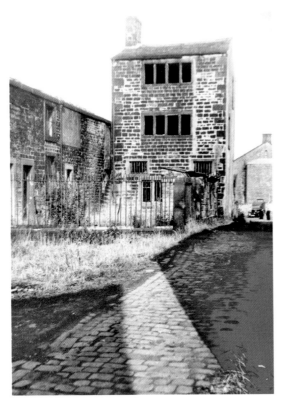

The Lock-Up

An excellent photograph of the old courthouse and town lock-up, which stood on the sett-stoned Newhouse Street for many decades. These buildings, originally eighteenth-century cottages, were brought into use as Colne's lock-up and courthouse during the power loom riots of the 1840s. Scenes were filmed here for the evocative 1951 film about the town's past named *Lancashire Pride*. Ten years later the lock-up and courthouse were pulled down and today all that has survived are stone flags on the bottom-right of our present-day picture.

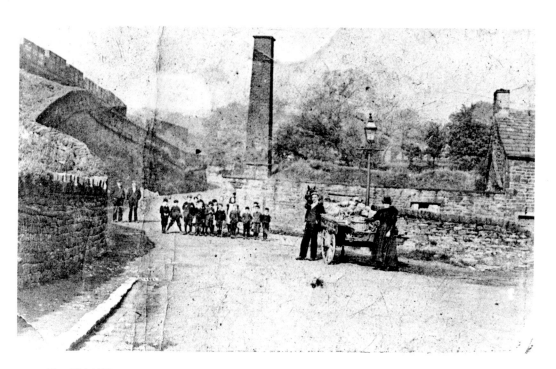

The Old Mill

A rare early picture of one of our town's oldest mills. This fulling (woollen) mill was pictured here in the mid-Victorian era, with the goods carriages of the midland railway seen towering above the old mill and curious Colners, as the cameraman records the scene for posterity. Our present-day view is taken some way back from the original photograph, but the railway is still to be seen on the left-hand side.

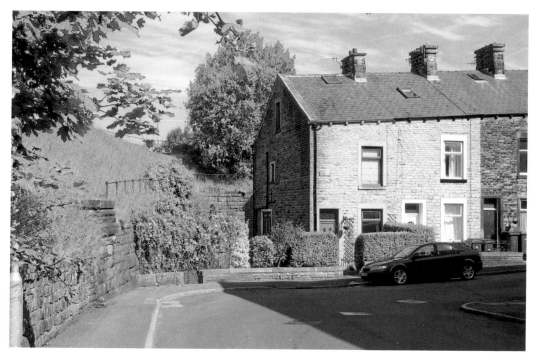

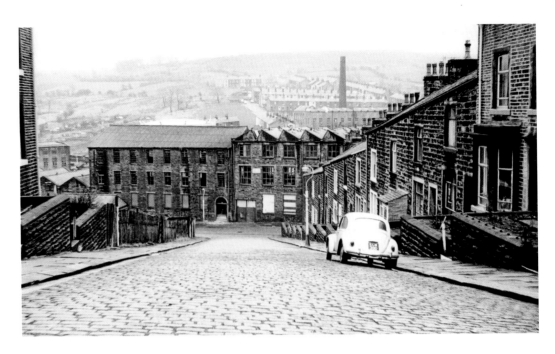

Colne's Steepest Street

Sutherland Street, which runs down from No. 89 Albert Road is Colne's steepest street. At the bottom of our 1970s scene we can see the last days of the once-mighty Great Holme Cotton Mill on Shaw Street, which was knocked down in summer 1975. Today this iconic Colne Street is still a challenge for its postal workers, especially on icy winter mornings.

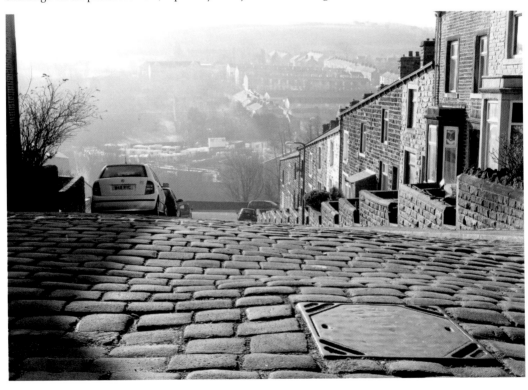

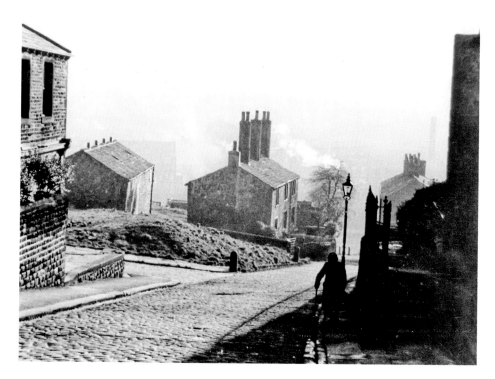

Colne Lane

Colne Lane, which runs down from No. 1 Church Street is another of the town's steepest thoroughfares. In 1929 the drop between Nos 2 and 114 was measured as 1:10. Note on our 1950s picture the eighteenth-century Tall Chimneys farmhouse. In spring 2011 tall maple trees are in bud where the old farmhouse once stood.

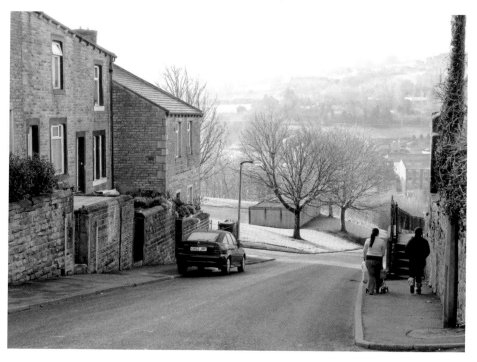

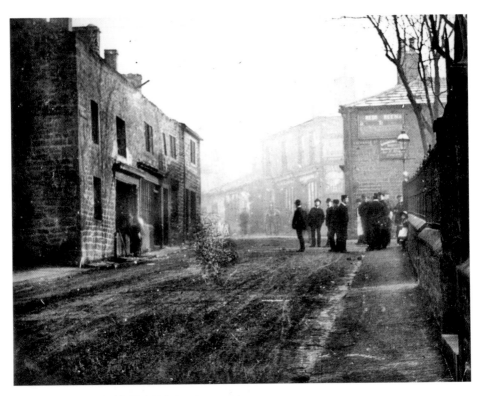

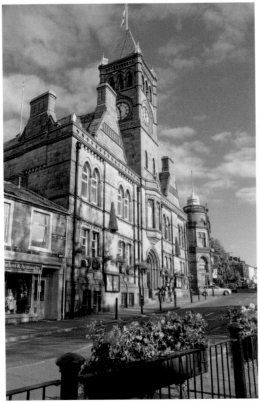

Halstead Fold

On the left of our 1890s photograph are ancient cottages of Halstead Fold, built in 1649 and sadly demolished in 1892 to make way for the town hall. Sir William Pickles Hartley's wife Martha was born at No. 2 Halstead Fold. Our up-to-date picture shows the magnificent building that replaced these long-standing cottages at this old-world corner of Albert Road.

Our Town Hall

Our imposing and noble town hall is seen here in 1894 and 2011. Opened on Saturday 13 January 1894 by Colne's first mayor, Samuel Catlow JP the central Gothic-style tower is 80 feet high and the clock dials are 7 feet in diameter. At the town hall's stately entrance is the largest flagstone in all of Lancashire. This huge Colne landmark is 9 feet 10¼ inches by 9 feet 1½ inches and 11 inches in depth, a truly gargantuan stone.

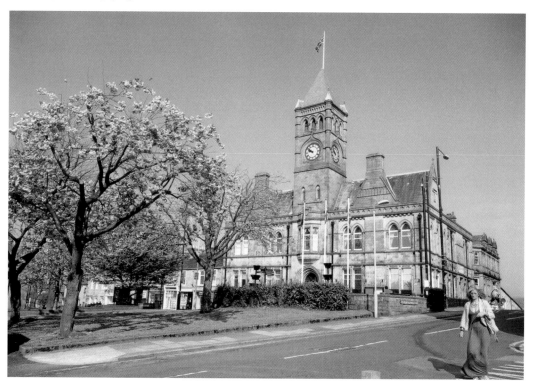

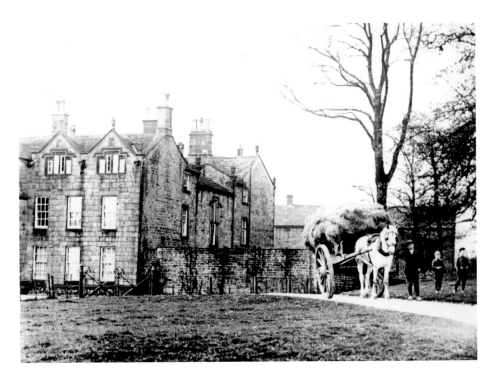

Alkincoates Hall

Alkincoates Hall was one of our earliest and indeed the finest of Colne's mansion houses. First mentioned in 1349, the hall was rebuilt in Elizabethan times in 1575 and modified further in 1720. The Parker family sold the hall and 92½ acres of land to the Colne Corporation in 1921 for £24,082. In 1957, fools in high places condemned this majestic building to demolition. Today, towering trees grow where Alkincoates Hall once stood proud and tall for centuries.

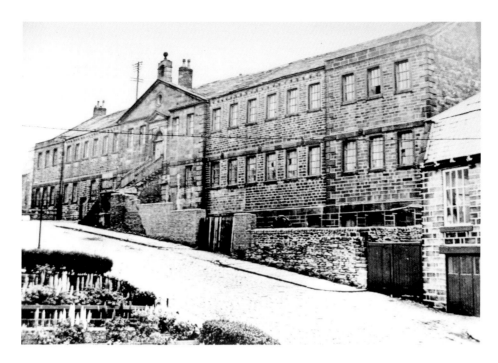

Cloth Hall

This dignified building was opened as the piece hall for our town's woollen trade in 1775. By the year 1810 King Cotton had taken over and the Cloth Hall, as it was now known, was visited by wealthy cotton manufacturers from across Lancashire. With the demise of the cotton industry after the Second World War the cloth hall became obsolete and tragically the renowned building was bulldozed in 1953. Today a tenth of the hall remains and here in one of the horses' hay mangers in early spring we can see wild coltsfoot.

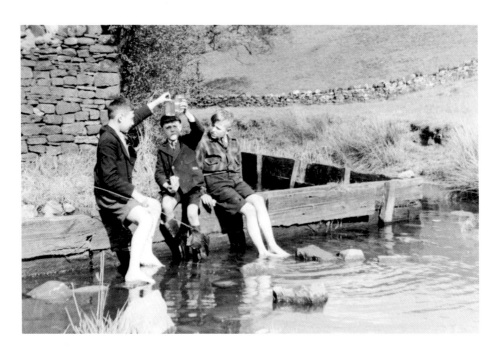

The Old Ford

Here we see the old ford at the bottom of Smithy Lane, which as our 1950s scene shows was an excellent place for catching fish to bring home in a jam jar. Smithy Lane is known to all Colners as 'Shirt-Neck Harry' after the legendary Victorian eccentric Harry Rycroft. Today at the ford no longer is anyone seen fishing for sticklebacks, there's just a poignant empty jam jar.

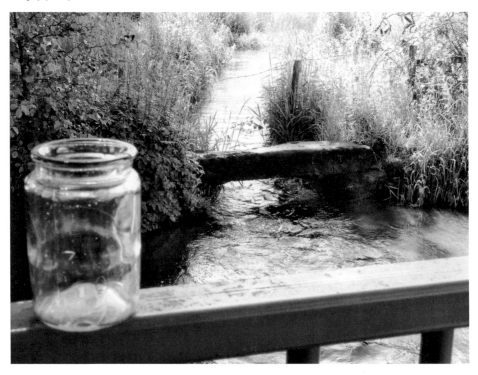

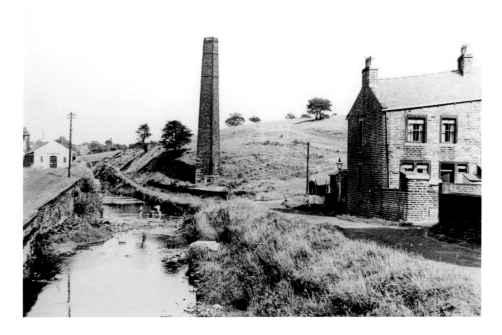

The Rap-Hole

Here's another tranquil 1950s picture, which shows more fishing in the river just by the Rap-hole Chimney. This waterside landmark belonged to Sam Smith's tannery, just across the river, and was known to everyone as the 'Skin Yard'. Our present-day scene on an early spring day sees no fishing now and the Rap-hole Chimney has long gone, as has Sam Smith's; only Wood Street remains on the right.

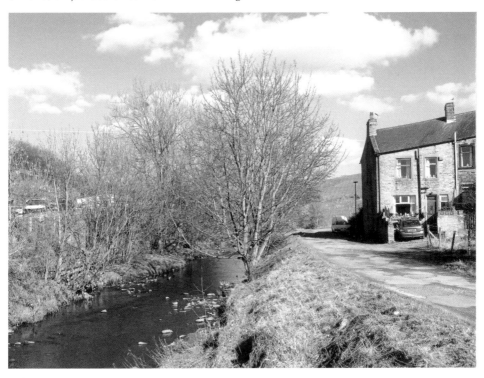

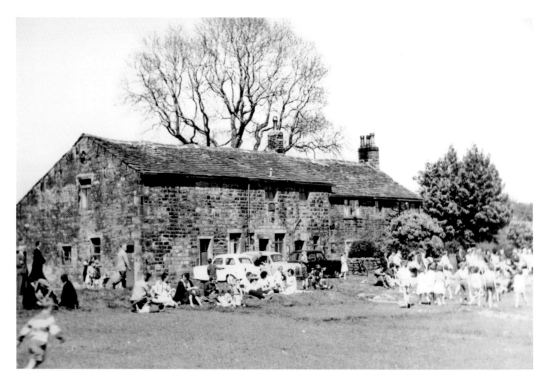

Holt House Cottages

A happy 1950s view of a day out up at Holt House with the ancient Holt House Cottages caught on camera so very well. Holt House, known to all in town as the 'Top Rec' was during the post-war years a Mecca for all budding cricketers and footballers and the left-hand side of the cottages was used as changing rooms. Today the long-standing cottages are gone and only the mighty ash tree remains as a silent sentinel.

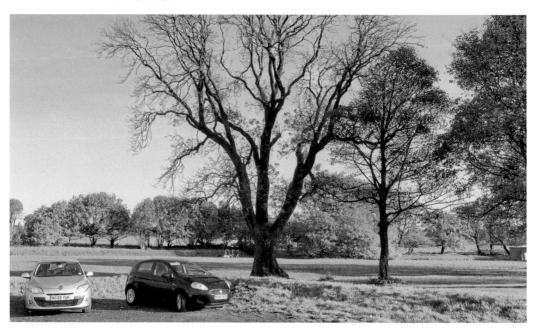

Myers House

Here we see Myers House and its cottages (four in total), which had stood at the bottom of Windy Bank for many decades. Taken in 1975 these splendid buildings were to only survive a dozen more years before being knocked to the ground. The area at the junction of Windy Bank and North Valley Road was also known as Stone Bridge Terrace. On the site today is the retailing giant Sainsbury's.

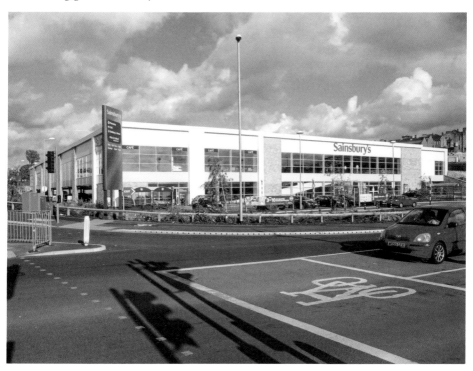

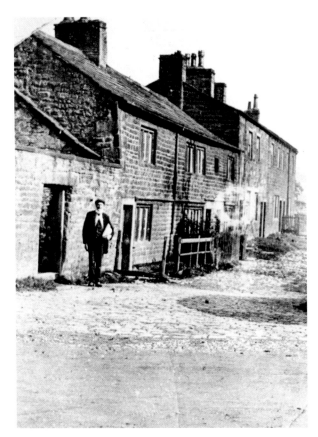

Ham and Egg Terrace

This is a rare and indeed a very old photograph, a view of the ancient cottages situated down the old road to Barrowford, which were known locally as Ham and Egg Terrace. Now named Guy Syke, the entrance to this original road was between the railway goods and grain warehouse and the Crown Hotel. Our up-to-date picture shows us the start of this old footpath which would originally have run all the way to the ancient farm at Priestfield.

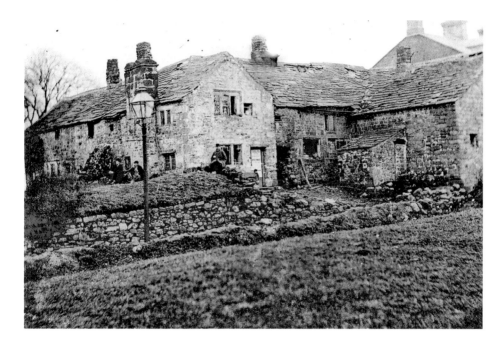

Old Colne Hall

Just as with the previous picture this one of Old Colne Hall on Albert Road is rare vintage – this historic hall was captured on camera a short time before its sad ending in October 1867. During the once-honoured hall's heyday in the year 1465 King Edward IV stayed overnight at the hall and in 1652 the old Colne Hall was valued at £1,158 2s 9d – a tremendous amount back then. Today, seen here from Hall Street, the classical 1906 Co-operative Buildings proudly stand where once our prestigious Old Colne Hall did.

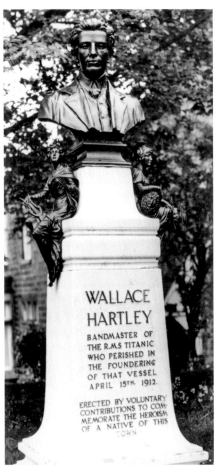

Wallace Hartley

He was born at No. 92 Green Field Hill in Colne in the summer of 1878 and on his death, on a fateful spring night in 1912; his name would become synonymous with heroism and his native town forever. Yes, Wallace Henry Hartley, who so courageously led his band to play as the RMS *Titanic* slowly sank to the depths of the north Atlantic Ocean and 1,523 were lost below waves, was that night the bravest of the brave. Our pictures show Wallace's memorial as it originally looked and as it still stands proudly today.

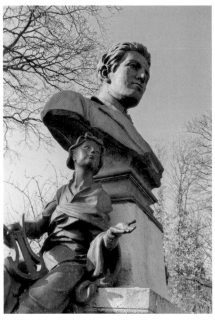

R·M·S TITANIC ·

A Hero for All Time

Here we see Wallace beside the mighty RMS *Titanic* and his signature along the bottom. The heroic Wallace's autograph is rated alongside those of Sioux Chief Crazy Horse and American author J. D. Salinger as one of the world's rarest signatures of modern times. I bought my Wallace Hartley autograph from Christie's in May 2000 for £2,875 and it has just been appraised for insurance for £10,500. Our up-to-date picture shows a magnificent Titanic floral display put together by the Colne in Bloom team in 2011, a wonderful tribute to our hero for all time.

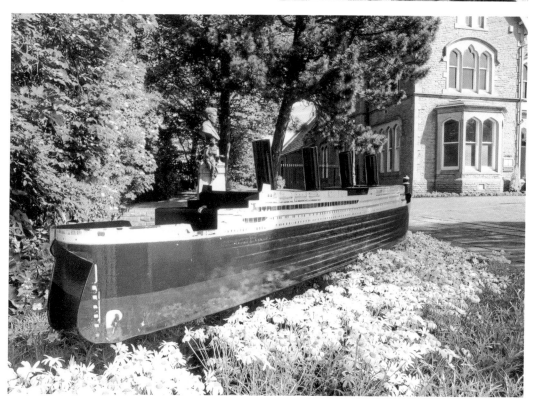

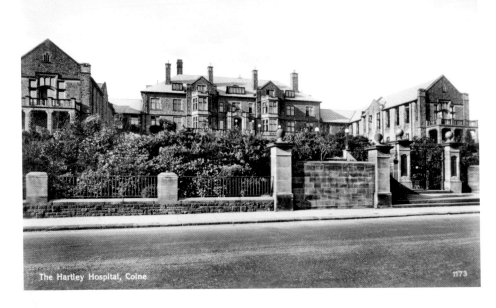

The Hartley Hospital, Colne 1173

Sir William Hartley

He was born at No. 8 Damside in Colne in the winter of 1846 and would become the founder of the mighty Hartley's Jam Empire and his native town's greatest benefactor. Knighted by King Edward VII in 1908, Sir William Pickles Hartley JP never forgot his humble beginnings and gave our town many magnificent gifts. Here we see one of his finest, the Hartley Hospital of 1924. Today much of this noble building has gone, leaving only the central structure encircled by new houses.

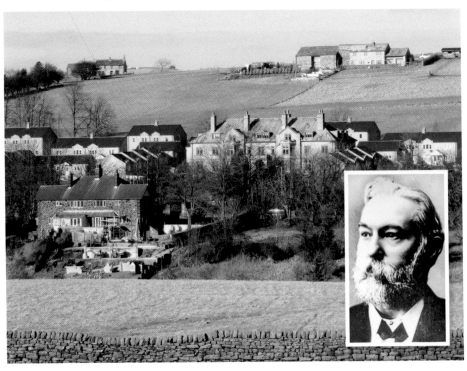

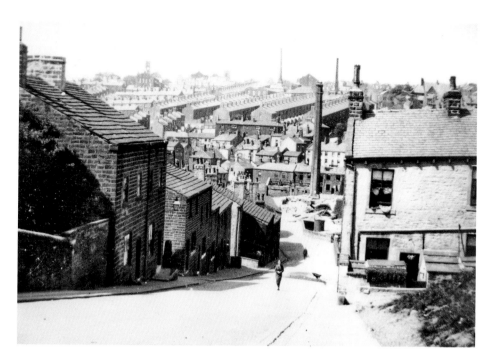

Peter Birtwistle

He was born at No. 32 Lenches Road in Colne in the Spring of 1842 and would make his fortune as a young man in Canada as a diamond merchant, later becoming a wonderful philanthropist to his place of birth. The Peter Birtwistle Trust set up in 1918 matured in 1948 realising £200,000, which has to date provided seventy-five fine bungalows in Colne bearing his name. Our pictures show the view down Lenches Road in the year 1935 and the same view over seventy-five years on.

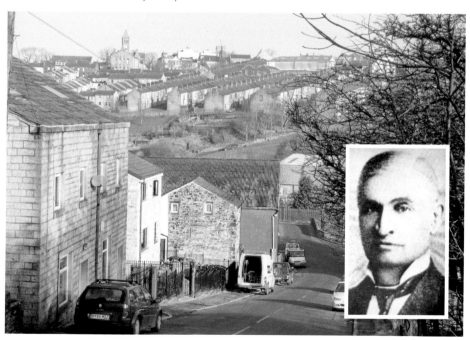

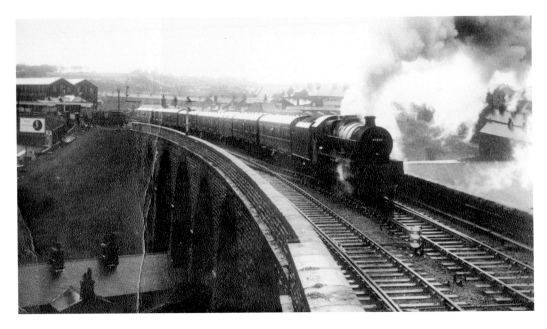

The Era of Steam

Gaze here on a sight we'll never see again. Steaming over our Victorian viaduct is the mighty steam locomotive *Ceylon,* number 45604 of the now-iconic LMS Jubilee Class, which is captured here during the halcyon era of steam. Our 1847 six-arched viaduct saw thousands of steam engines flashing by in a cloud of smoke and steam until the very last one in 1968. Today a single track carries a DMU Railbus Class 142, number 142046, making its way to Blackpool – no contest!

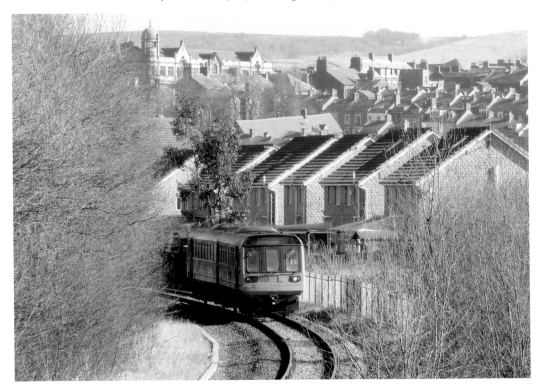

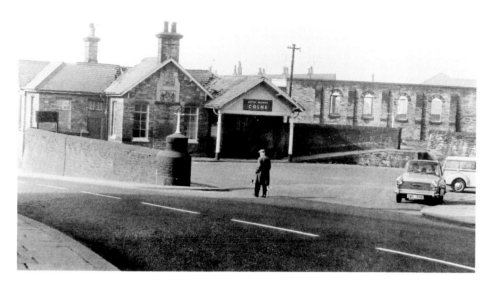

Colne Railway Station

On 2 October 1848 the Colne to Skipton line was opened and on 1 February 1849 the Colne to Burnley section became operable, making Colne's Midland Station busy indeed. Rebuilt in 1883, by the Edwardian era our proud station would see fifty-five trains on the up-line and fifty-four trains on the down-line running at full steam every day. As the swansong of steam arrived our station was marking time. Firstly recommendations by the brazen-faced Beeching saw the Colne to Skipton line closed in February 1970 and by February 1972 the station was being bulldozed down. Today only the station wall survives.

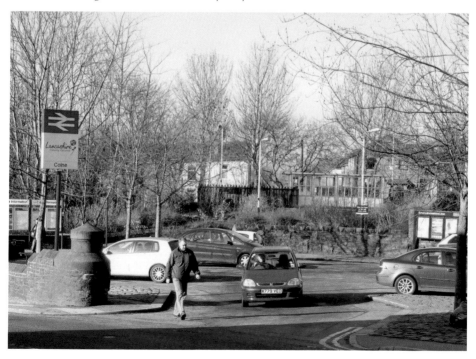

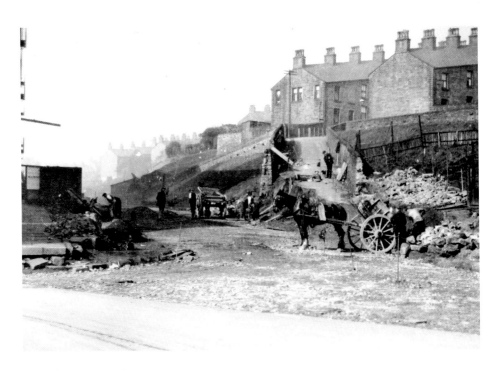

A Road to Waterside

Here we see an excellent late Victorian scene, which shows the old road leading to Shaw Street from Duke Street being laid down by a team of workmen. This, along with Exchange Street and Colne Lane, was always a popular route to old Waterside. The sett-stoned path is known to Colners as 'going down to the stumps' and was a great highway for sledging from the top of Duke Street right down to Shaw Street. Today the old-world path is little-changed from yesteryear.

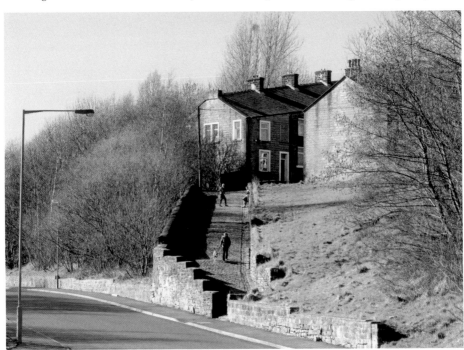

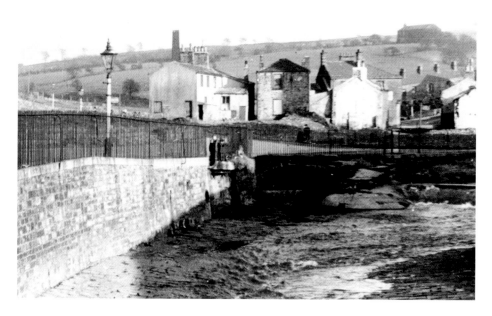

The Beck

This is the South Valley's Colne Water, known by all Colners as 'the beck'. Our 1953 scene shows the view along the beck to the last few houses of old Waterside. Here, still standing, are the ancient cottages of Duerden's Yard that were shortly to be knocked to the ground. Also seen is the Old Duke Inn, now one of Colne's lost public houses. Happily, in our 2011 scene we see the last of the four waterside inns, the Admiral Lord Rodney Hostelry, a true survivor.

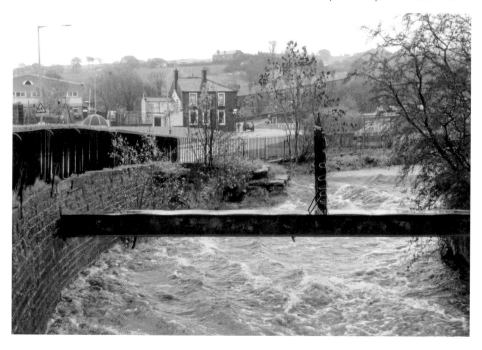

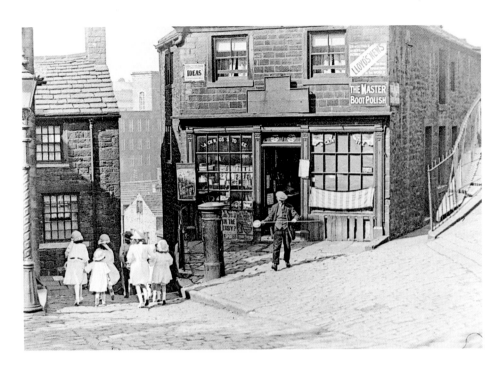

Colne Lane Post Office

A classic 1920s scene which captures so well the old Colne Lane post office known as 'Jackson's' and a group of most elegantly dressed young girls. The cloth-capped gent is ready for a spot of fishing in the beck while through the gap is visible the five-storey Haslam's cotton mill, which would sadly close in 1931, making over 600 workers redundant. Today all has gone from our scene except the Spring Gardens Mill.

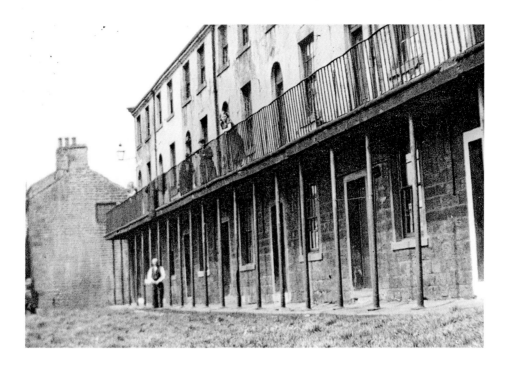

The Landings

Here are the legendary 'Landings', situated on the hillside just below the old Colne Lane post office. These waterside iconic and unique houses had the official names of Bank Terrace North and Bank Terrace South, but everyone knew them as 'the Landings'. Demolished during the 1930s the huge metal poles were still on the site twenty years later. Today the whole area is tree-lined and grass-covered.

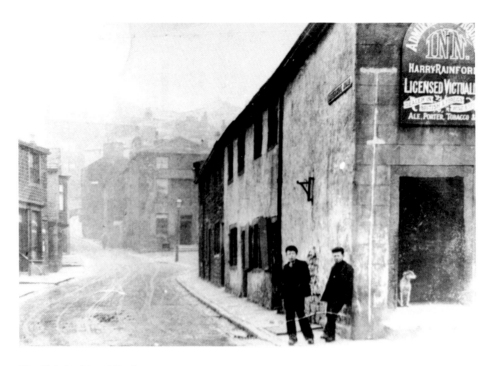

The Original Lord Rodney

A rare photograph of the original Admiral Lord Rodney Inn, with the Robin Hood Inn in the background. The Lord Rodney was built in 1792 and named after the first Baron George Brydges Rodney (1719–92) the British admiral who won sea battles against France and Spain. A new Lord Rodney Inn replaced the Georgian building in the mid-1920s and this is the present day inn as in our colour picture.

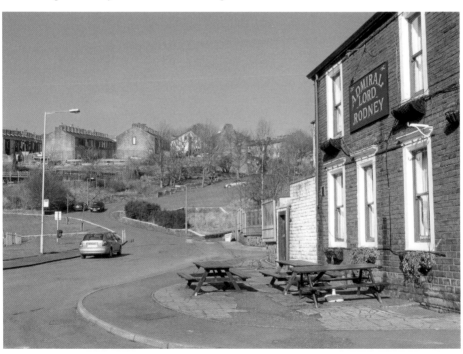

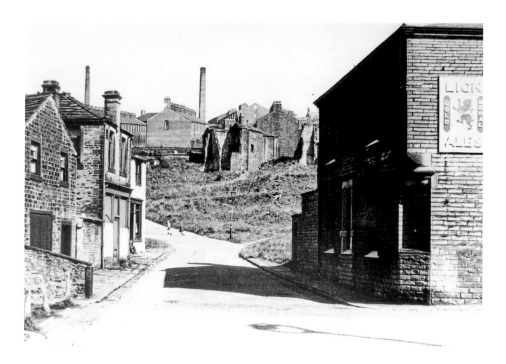

A Popular Place

Here is Waterside in the 1950s with the Lord Rodney on the right and the entrance to Duerden's Yard on the left. At this time the Lord Rodney was run by the affable hosts Alan and Vera Barrett, who in 1957 revived the ancient waterside tradition of the 'Wapping Pash', a marvellous celebratory get-together. Today, as seen by this gathering of local bikers, the Lord Rodney is still a most vibrant and popular place.

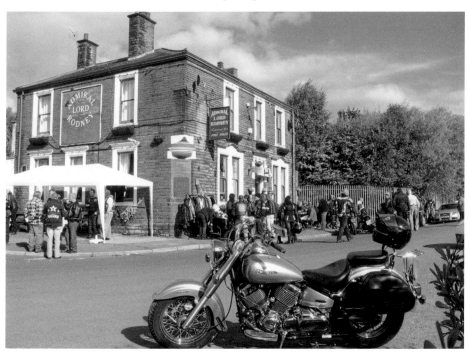

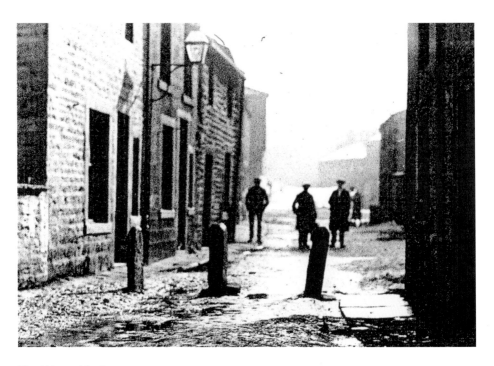

The Waterside Stoops

An excellent 1920s view looking towards Waterside Bridge, and which shows so well the Waterside Stoops. The three stones were put in place to protect the mill race which was covered over in the early Victorian era and ran from the Corn Mill. Having stood for over 140 years, in 1977 the ancient stoops were ripped up by a travelling fair. To preserve these unique stones I took them to a sylvan glade in Alkincoates Park, as our colour picture shows today.

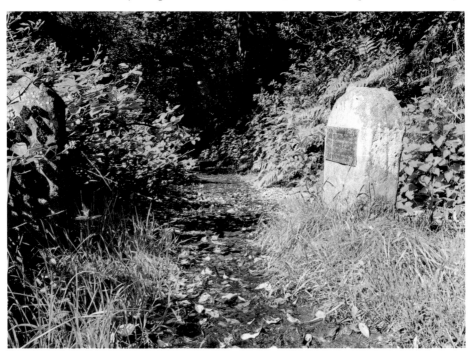

The Providence Church

Looking down Lenches Road in 1972 we can see the last days of the monumental Providence Independent Methodist church, which began its days as the Primitive Methodists in 1821. Opposite on the left are my co-author Colin's two sons, Andrew and Russell, and just in front we can see a rare George V post box. The proud Providence hit the ground in 1973 and today Colin's sons are in their forties. As the 2011 picture shows, the lamp box has long gone, just as the Providence has.

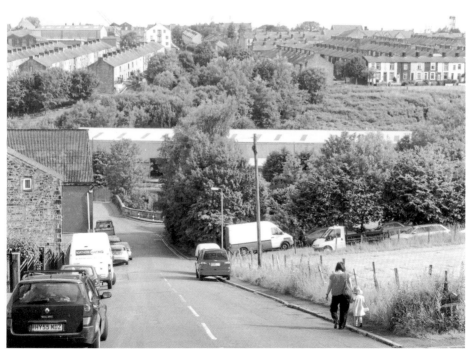

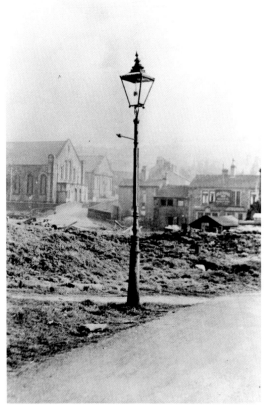

Our First Gas Lamp

A rare 1940s view of the aftermath of the first stage of the demolition of Waterside. To the left in the background is the impressive Victorian duo of buildings that make up the Providence church and Sunday school. To the right is the Old Duke Inn of 1709, whilst standing proudly in the centre is Colne's very first gas lamp from 1840. Gas Street, which housed the gasworks, was a stone's throw away and today the original gas lamp from Croft Corner is seen here (sadly topless) outside the new Providence church on Albert Road.

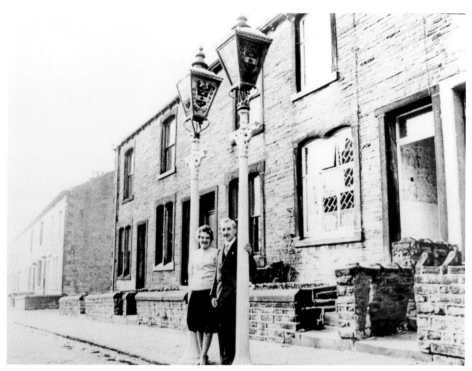

The Mayoral Lamps

Our mayoral lamps, of which there are two, with coloured panes of glass depicting the Colne coat of arms, have proudly stood outside the homes of every one of our 46 mayors from Samuel Catlow JP of 1895, to James Ilott of 1974. Our picture shows the mayor and mayoress, John Whalley and his wife Winnie, outside their home at No. 32 Brown Street West, where they became our town's first citizens in the year 1963. Today, the mayoral lamps are preserved, albeit absurdly apart, outside the Market Hall and in the library.

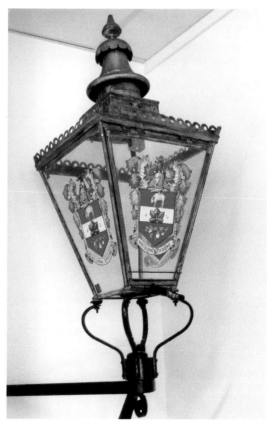

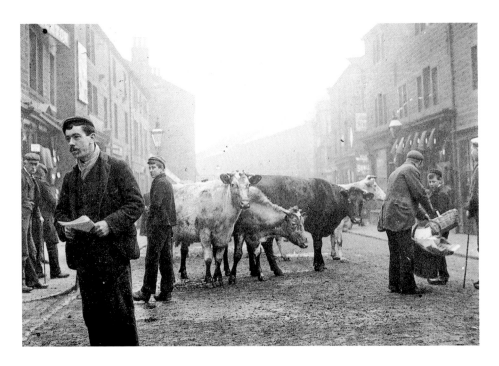

The Last Cattle Fair

A wonderful moment in time, captured on Market Street as Colne's last cattle fair is held in February 1897. These street cattle auctions took place on the last Wednesday of every month and saw hundreds of prize cattle paraded through town. In June 1905, a cattle market was opened on Ludgate Circus where, as well as cattle, pigs and sheep were put up for auction weekly on Friday and Saturday. Today this stretch of Market Street sees no more bovine beasts and likewise our cattle market closed in June 1957.

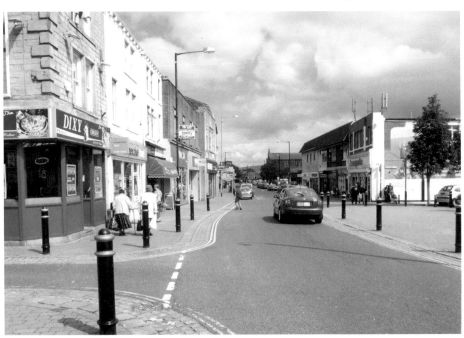

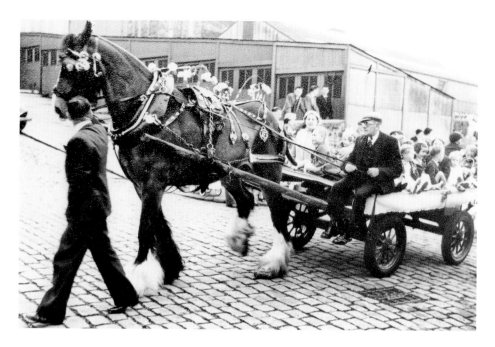

From Horses to Tractors

Here we see the majestic horse, Roger, eighteen hands high with his proud driver Harry Carradice at the 1955 Whitsuntide parade. Harry and his much-loved shire horse delivered coal in Colne for over thirty years. Today horses are a rarity on our streets and on farms everywhere have been replaced by the ubiquitous tractor. Here, with his farm tractor is our affable dairy farmer Harry Waite of Wanless Water Farm. Harry and his family have delivered fresh milk to our family since 1940 – first Harry's father, John, with his white horse Prince and milk cart, then Harry and his wife Jean, followed by their genial son David, and now David's son Thomas lends a hand too.

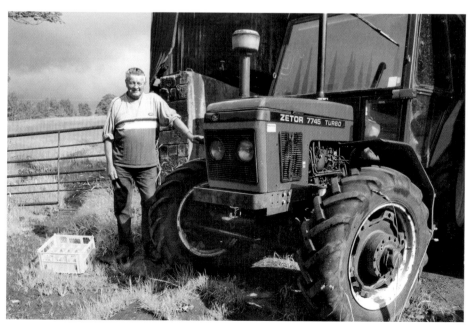

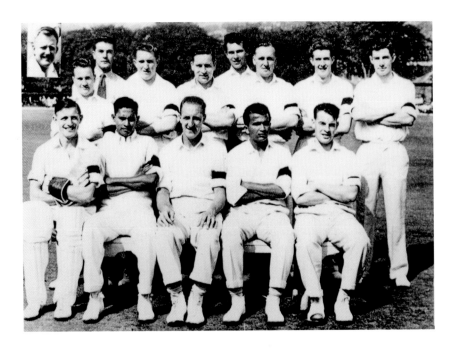

The Renowned Double Side

A glorious side of talented players, these are the men of Colne Cricket Club who made history on the Horsfield in the summer of 1959 by winning the League Championship and Worsley Cup. The 'double winners' are, back row left to right: Gordon Pickles (inset), Jimmy Wild, Ray Baron, Malcolm Blackhurst, Brian Hurlstone, Geoff Hall, Geoff Schofield, Billy Greenhaugh and Peter Hargreaves. Front row, left to right: Terry Reeves, Stanley Jayasinghe (PRO), Frank Taylor, Tyril Gauder and Bobby Little. In our 2011 picture we see a smiling Jimmy Wild return to the Horsfield, the place of his greatest year, 1959.

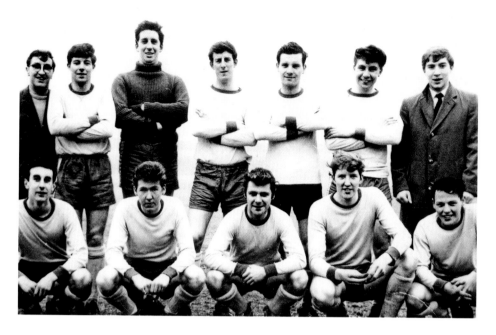

The Celebrated Dynamoes

These are the skilful players of the mighty Colne Dynamoes FC, captured during their first season of 1963-64. Twenty-five years on, the club would win the prestigious FA vase at Wembley in 1988. The notable team that began it all are, back row left to right: Edward Ormerod, Keith Carradice, Brian Clark, Rodney Booth, Peter Bradley, Gordon Ellis and Trevor Riddiough. Front row, left to right: Mick O'Shea, Graham White, Peter Skelton, Trevor Lonsdale and David Heaton. Not on our picture are the remarkable triumvirate of Gibbons brothers Barrie, Keith and Peter. In our 2011 picture we see a beaming Gordon Ellis return to Holt House, the scene of his team's many victories.

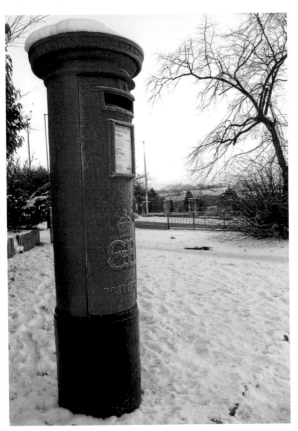

A True Rarity

A picture from 1977 shows a truly rare piece of street furniture outside the Lost Knotts Lane post office (closed 21 July 1992). This is the 1936 'A' type King Edward VIII cipher pillar box of which today only a handful remain. This box was installed in July 1936 and numbered as 306 box. Note also the rare 1936 stamp vending wall-box. When the Knotts Lane post office closed, the 306 box became little used and so working for the Royal Mail back then I managed to relocate our rarity to Hyde Park. Our colour picture shows the Edward VIII box now numbered 325 standing tall on a snowy day at Hyde Park, where we hope it will stand for many many more years.

Saved Just in Time

Here, pictured in 1998 are my five-year-old grandson Nathan and myself outside our former Crown post office. Alongside are twin 1935 King George V Jubilee telephone boxes. These Sir Giles Gilbert Scott design K6 kiosks are now becoming scarce indeed and previous to our picture they were to be taken away. Our Colne sorting office (closed in 2000) got a petition going, which collected in just two weeks 856 signatures that saved the day. In the modern scene, our classic Jubilee boxes are still *in situ*, albeit ready for painting, and smiling out on Albert Road we see eighteen-year-old Nathan and 'your truly' back with our iconic kiosks.

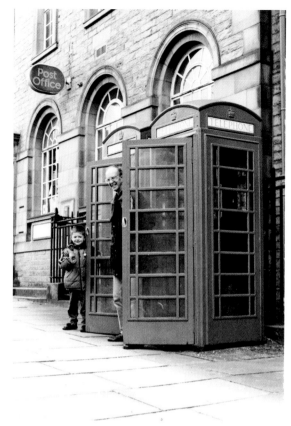

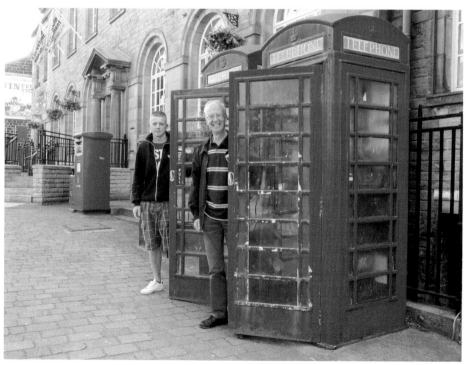

53

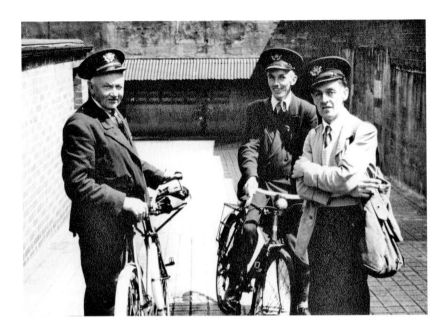

From Bikes to Vans

It's Coronation year, 1953, and here at Colne's Royal Mail sorting office on Albert Road we see a trio of smiling postmen just returning from their first delivery at around 9.45 a.m. by bicycle. Here, left to right, are Jimmy Laycock, Bob Gregson and Johnny Strickland; marvellous characters, all three. Push-bikes were used on a number of duties at Colne back then; however, today they have been superseded by ultra-modern delivery vans for both town and rural rounds. Our colour picture shows well-known postman Jimmy Waddington, our area's golden cue snooker champion, on duty with a brand new Vauxhall postal delivery van.

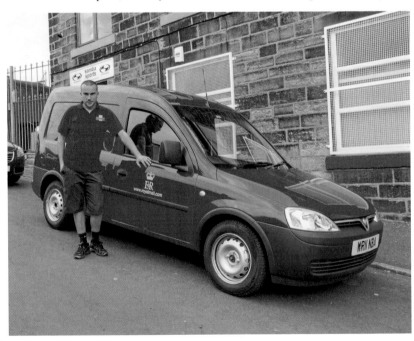

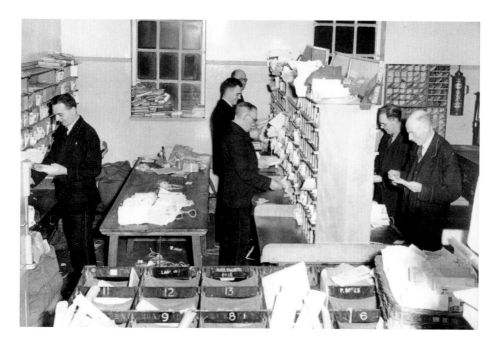

Colne Sorting Office

A rare view into the 1928 Royal Mail sorting office with the male staff busy at 5 a.m. doing the inward sorting ready for then preparing their walk duties and out on delivery by 7 to 7.30 a.m. Between 9.45 and 10.15 a.m. they would return to sort the second delivery of mail and both deliveries would be completed by 12.30 p.m. It's all a far cry from today, but our 1951 picture bears little resemblance to today's modern sorting methods. The postmen of sixty years ago seen here include Jim Harris, Tommy McDermott, Jack Wareing and, on the left, Ken Speak, our office's 'fastest sorter of all time'. No ladies at Royal Mail back then; however, today they are numerous. Here we see long-serving beauty Lisa Day ready to commence her rounds.

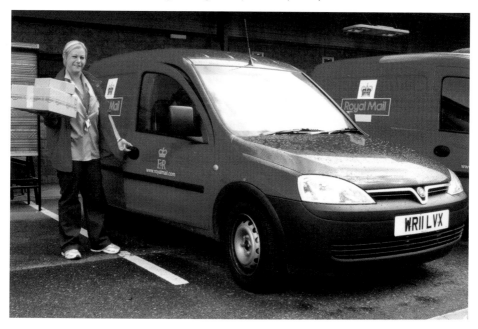

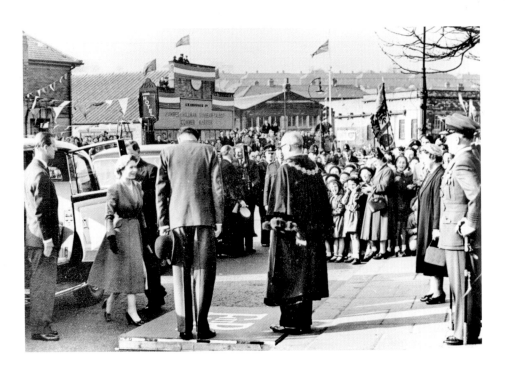

The Queen Comes to Colne

Thursday 14 April 1955 on a wonderful sunny day our young queen came to Colne. Tens of thousands lined the streets to welcome her to our ancient market town. Here, just in front of the North Valley Hotel, Her Majesty stepped out to meet our proud mayor, John Edgar Driver, with happy faces all around. It was a day of history and joy that myself and thousands of Colners will remember always. Today, the 1940-built North Valley Hotel is a plumber's merchant's and also no longer trading are G. W. Rushworth Ltd, Humber, Hillman and Sunbeam Talbot, car dealers of note.

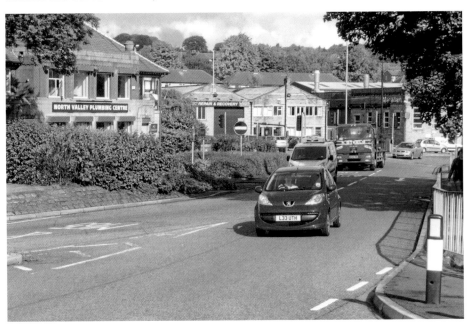

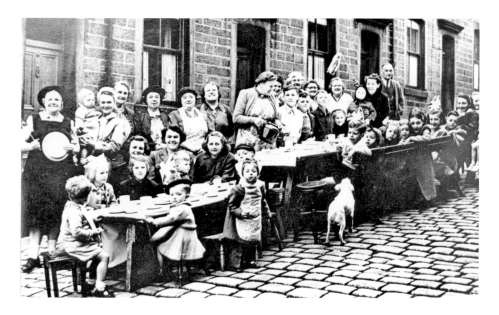

Our Street Parties

When Queen Elizabeth II was crowned on Tuesday 2 June 1953, our town celebrated with hundreds of street parties. Here we see the happy occasion on Duke Street with well-known Colners including Pat and Jimmy Powley, Ann and Sylvia Dixon, Nora Mabbutt with sons Ray and Ken, and Joan Thornton with sons John and David. Also here is Clara Whittaker JP Colne's first lady mayor in 1966. The modern photograph of smiling faces commemorates the 2011 Royal Wedding of Prince William and Kate Middleton on a bedecked Brown Street West. Here we see a beaming Vera Templar with family members Susan and Joel, Gail Waddington and Jade Braithwaite who, along with many others, had a marvellous day.

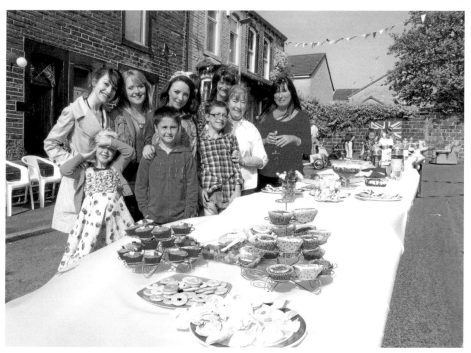

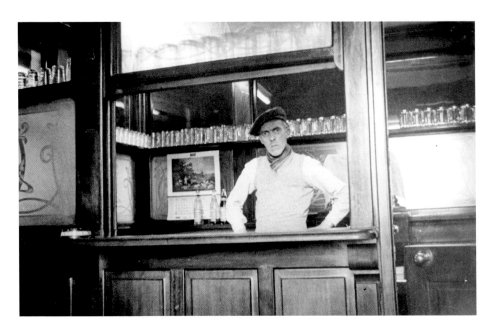

The Dressers' Club

In this 1946 picture we can see cloth-cap steward Harry Potts behind the bar of the Association of Preparatory Workers Club at No. 2 Hall Street, which is today one of the town's last working men's clubs. Only three now remain of the pre-war sixteen. This popular social meeting place is known to all locals as the 'Dressers' Club' and gained fame in 1949 when appearing on television with the legendary 'Dressers' Brains Trust'. Today, behind the little-changed bar is the vivacious lady steward Dianne Monk, who proudly keeps the Dressers' successfully running in the twenty-first century.

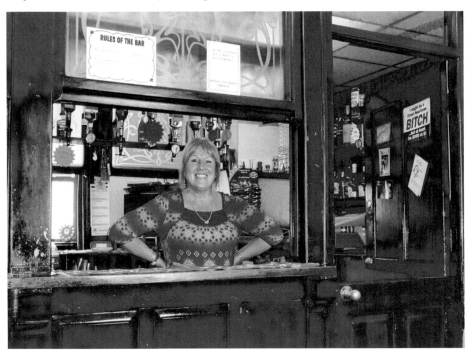

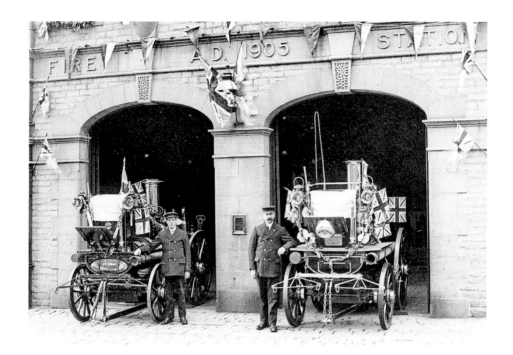

Our Edwardian Fire Station

A superb scene from the Edwardian era showing Dockray Street fire station in 1905, with two immaculate, prize-winning fire engines of the day. Colne's first fire engine was named *The Bold Venture* and dated back to 1886. Today, the former fire station is 'Whitesides', the notable high-class confectioner's. Here, outside the shop, we can see the members of the Pendle Rally Chopper group. Amongst them are the legendary clog-wearing 'Billy Bantam', AKA John Dixon, Linda Dixon, Jake Dixon, Ben Ormerod, Carl Pawson, Richard Bone and John Bridges and family.

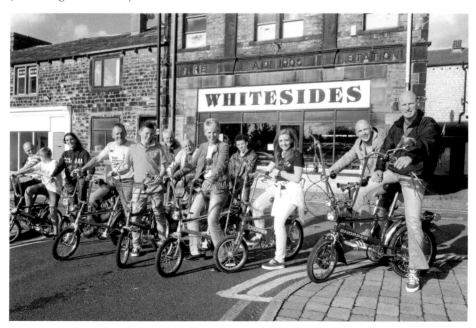

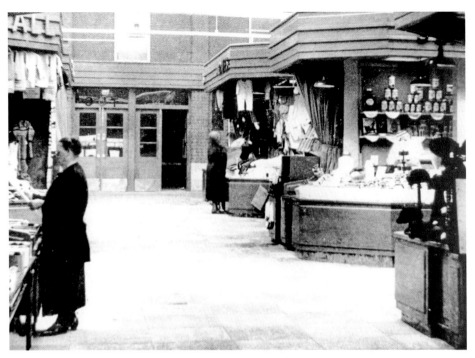

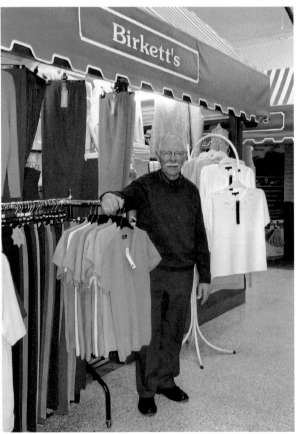

Our Market Halls

A photograph from 1937 gives us a glimpse into Colne's new Dockray Street market hall, replacing the original 1898 hall, which burnt down in 1935. The stall on the left was the much-loved Bolton's toys and books stall with Mrs Bolton seen here. Another well-remembered stall in the hall was Birkett's, which sold ladieswear, linen and household goods, founded by Gertrude Birkett in 1947. Her son Maurice took over in 1951 and in 1973 moved into the new £212,000 market hall in Market Street. In our 2011 picture we can see Maurice in retirement after sixty happy years, now handing over the business to his nephew, Andrew.

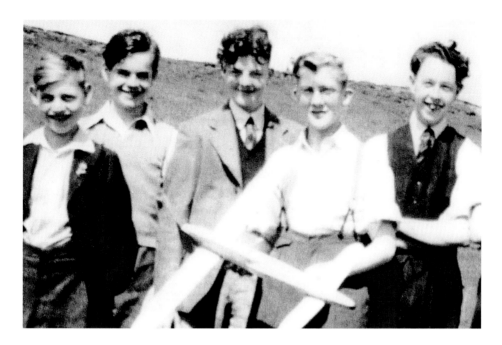

Arthur 'Yogi' Garnett

Here is, without a doubt, our town's best-known character. His smiling features and witticisms have been making Colners laugh for many decades. Arthur Garnett, known to everyone as Yogi, is seen here in 1945 with his fellow members of the 'Colne Model Aero Club'. Left to right, they are, Arthur Seel, Jack Miller, Ronnie Parker, Raymond Heyworth and Arthur himself with his model aircraft. Flying forward sixty-six years, we see a jovial Arthur complete with aircraft at his highly successful model aero and diecast vehicle business. Arthur, very much a family man, with seven children, will next year celebrate with his dear wife Margaret their Diamond Wedding Anniversary.

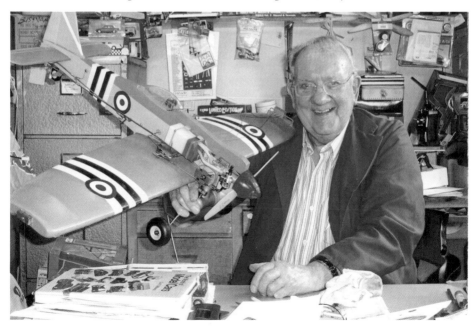

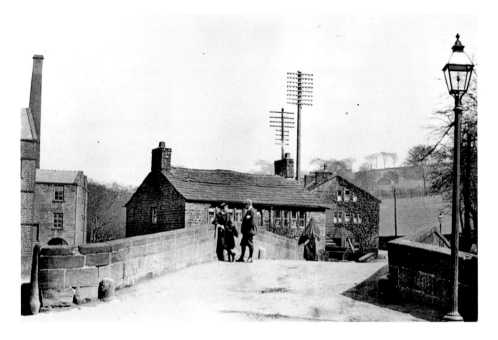

Old Carry Bridge

A splendid Victorian glimpse of Carry Bridge as it looked before its many houses and cottages were demolished. On the left is Richard Sagar's cotton mill, which was burnt down in June 1842 by power-loom rioters. Richard rebuilt his mill in cast iron and stone. Just over the bridge, the ivy-clad house is the home of Frank Slater who composed the heart-warming local anthem 'Bonnie Colne' in 1872. Today, Carry Bridge still had an old-world charm, with its meandering river hosting herons, dippers and sweet-singing willow warblers.

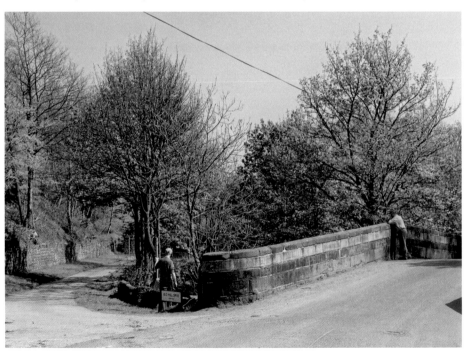

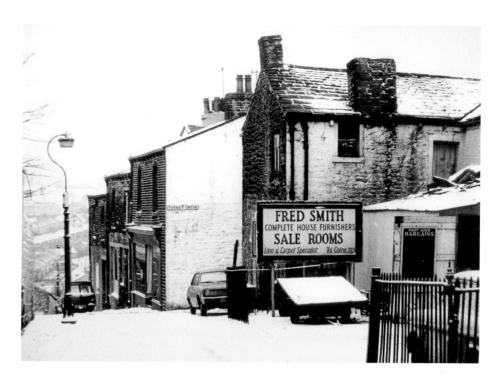

A Snowy Ivegate

A wintery day *c.* 1959 down Ivegate with the ancient Turney Crook's entrance in the centre. The eighteenth-century building on the right was originally a blacksmith's forge, later becoming the college glee club for many years. At the time of our picture, Fred Smith was running his furniture and antiques sale rooms, then in September 1960 it became the Mayfair Youth Club. Some of the happiest days of my life were spent here, at seventeen with great friends – Mel Hartley, Dave Horsfall, Sue Kibble and Sheila Morgan – listening to the sounds of the Everly Brothers, Roy Orbison and The King, Elvis Presley. Today, everything seen here has gone forever, and been replaced by modern housing.

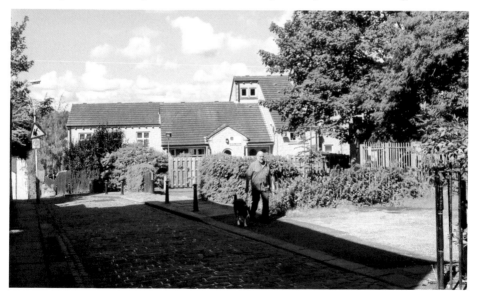

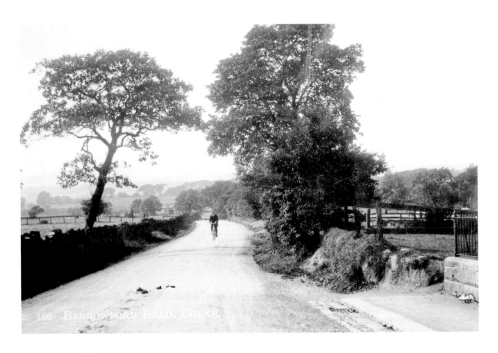

Barrowford Road

A tranquil country lane with just a lone cyclist to be seen in this splendid 1920 rural scene. This is the Barrowford Road of almost ninety years ago. Within a decade houses would be built all along the right to the Barrowford boundary and the Colne Grammar School opened on the field to the left in September 1941. This architectural gem lasted just thirty-five years until its closure in 1976. The last headmaster was James Petrie Allison. Today, this once quiet corner of Colne has a huge housing development at the grammar school and its terrain. In a quarter-mile stretch of road there are over a dozen speed bumps.

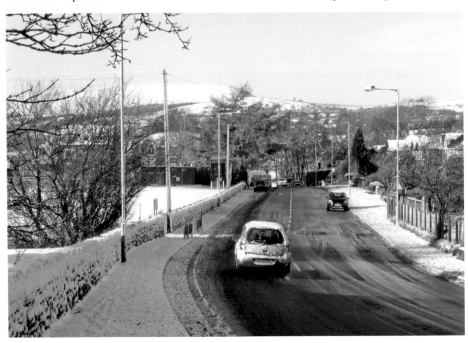

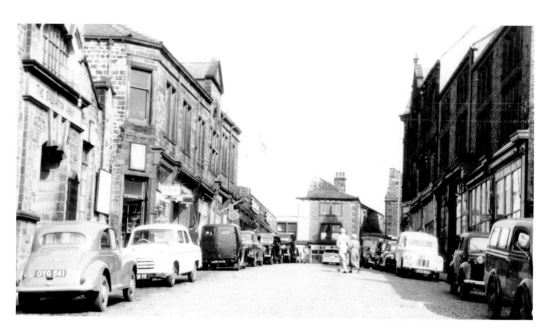

Swan Croft

An excellent view of Swan Croft in the mid-1950s looking up to Market Street. Swan Croft was originally Swine Croft and today carries the name Market Place. In the 1950s, Montague Burton, the tailor's, was top left with George Wraw's general stores and pawnbroker's top right. Also on the left was gent's hairdresser Allen Hargreaves, one of the fifteen barbers in Colne back then. At the bottom left is the Salvation Army citadel, which is today the Citizens' Advice Bureau. The original Bay Horse Inn, centre top, is gone, replaced in 1977 by the modern health centre.

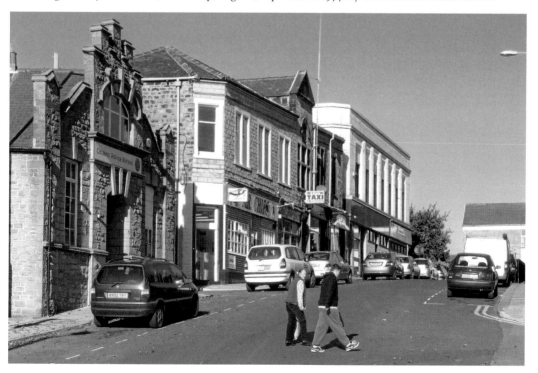

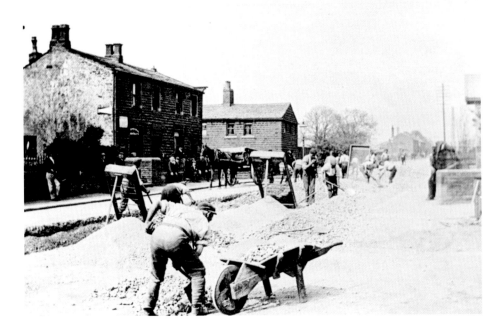

Burnley Road

A historic journey now, as we travel all along Colne's main road. Here we commence at Swinden Lane on Burnley Road as tram lines are being laid down in the spring of 1903. This corner of old Colne had the ancient Long Swinden Farm below Swinden Lane. Further east was the White Halls race course later becoming the venue for the circus coming to town. Today, Swinden Lane survives although the traffic levels are, at times, astronomical.

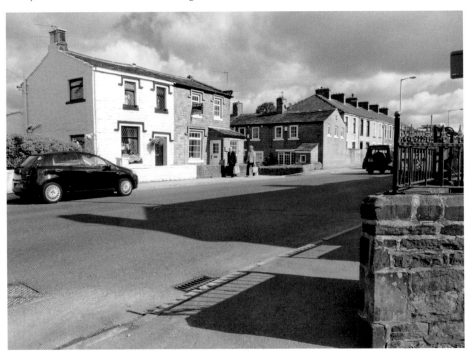

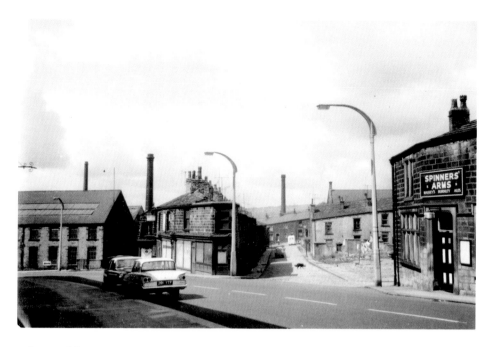

Primet Bridge

Up to Primet Bridge now and here in our 1950s scene is the Spinners Arms public house. With the recently demolished Dundas Street site to its left. Both End Street and Collingwood Street are here and Rodney Street runs along the centre. The shop at the corner had, for years, the famous sign 'Whitewashing done in all colours'. Further down at No. 6 Greenfield Road was the well-known Bert Tyrer's barber's shop. Today this part of town has changed immensely.

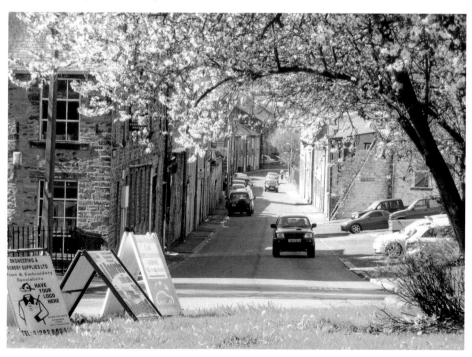

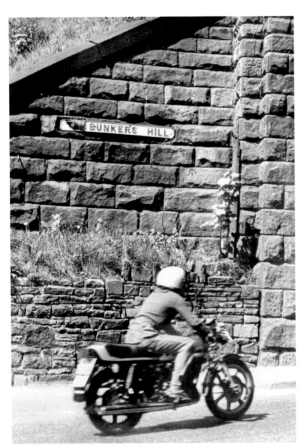

Bunkers Hill

Here in 1975, a motorcyclist flashes by the original 1890 cast-iron nameplate complete with a hand pointing to the area of Bunkers Hill, named after the nearby coal bunkers. This sign was unique in our town and, sadly, in 1977, suddenly disappeared. A new modern nameplate went up, albeit with no hand, not long after and survived until 2010 when it also vanished. Today, as seen in the 2011 picture, Bunkers Hill remains anonymous.

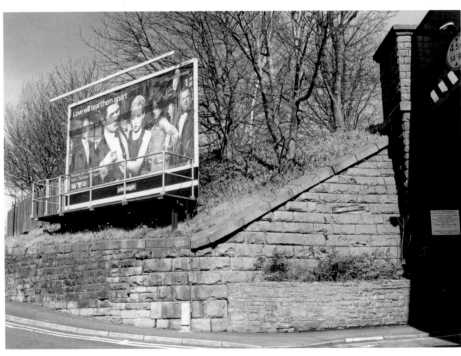

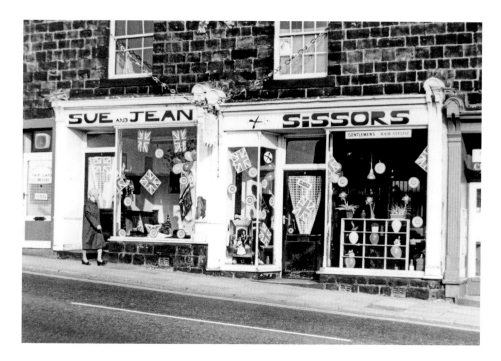

Primet Hill

Primet Hill in the Queen's Silver Jubilee year, and at Nos 1 and 3 is 'Sissors', the unisex hairdresser's, decorated in fine celebratory style. This well-known business was run for many years by the attractive duo Sue Southworth and Jean Ingram, who are still fondly remembered today. The lady on the left is my dear mother-in-law, Alice Burnett. Alice, a true Colner, had a family of ten children and lived to the ripe old age of ninety. Today, the row of shops still attracts many customers.

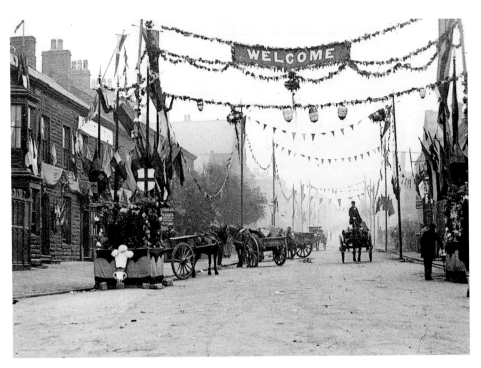

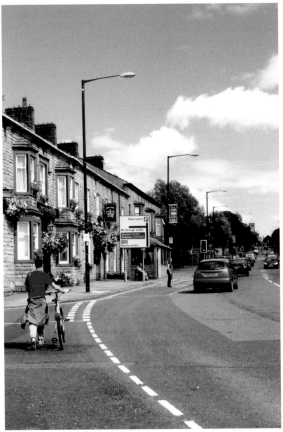

Albert Road

Our town's glorious Charter Day, on Saturday 14 September 1895. Here, by the commanding Crown Hotel of 1852, is a banner welcoming everyone to Bonnie Colne on the historic day to remember. Albert Road was originally Westgate, then Manchester Road and finally became Albert Road on the death of Prince Albert in 1861. Today, the cordial Crown Hotel serves up the very best food in town, as you are greeted by sociable hosts Noel Buckley and Steven Edgington.

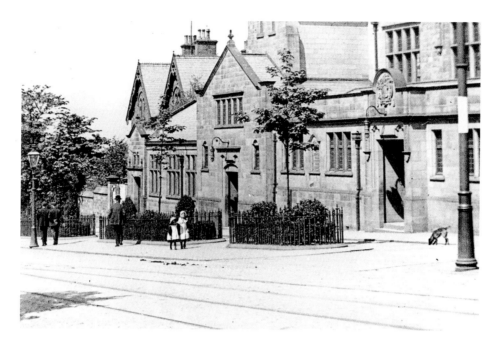

Municipal Hall

Here we see Colne's magnificent Municipal Hall as it looked on its opening in 1902. At the same time, the adjacent Gladstone Street became the more imposing Linden Road. The 1,000-seater hall has seen many famous faces over the years, from the contralto singer Kathleen Ferrier to the comic jester Ken Dodd. In the years 1949–51, I was most fortunate to have my dear mum and dad throw my birthday parties for all our street at the Muni'. Happy days indeed. Today, the Muni' is the main venue for our celebrated annual Rhythm and Blues Festival.

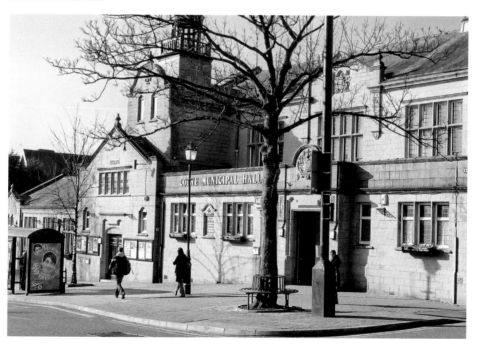

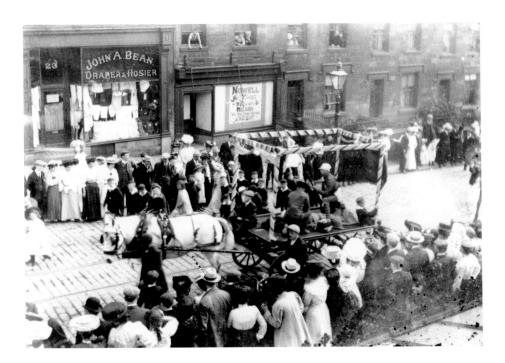

Family Shops

An Edwardian scene with Albert Road captured in fine style here as crowds of sartorial Colners gather to watch a grand procession. The shop on the left at No. 23 Albert Road is the draper and hosier John A. Bean's fine establishment – my co-author Colin's great-grandfather. Coincidentally, three doors down at No. 29 was my father Richard's pet store from 1949 to 1961, where aviaries housed hundreds of budgerigars and canaries. Today this is still a prime area for shoppers.

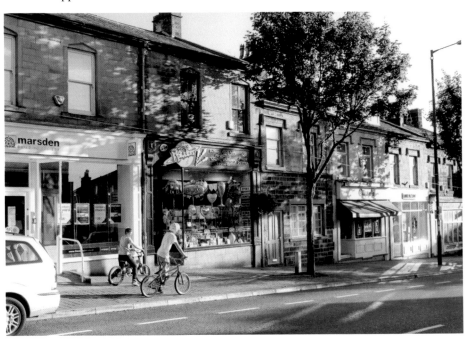

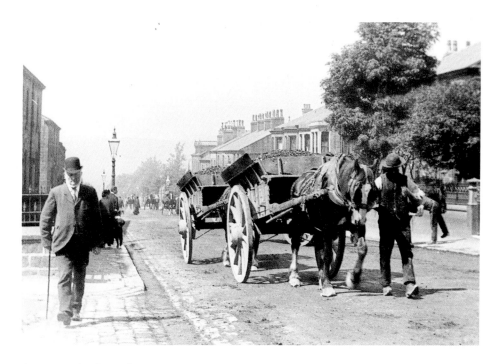

Our Tree-Lined Road

Splendid trees have always featured all along Albert Road, and our Victorian scene shows those outside Albert House and further down the road at the new Colne Hall's palatial entrance (built in 1868). The bearded gent with bowler hat and walking cane on the left is wealthy businessman Ambrose Barcroft. In our 2011 scene, tall trees line Albert Road's full length. On the left we see the long-serving and much respected Colne library research archivist Christine Bradley.

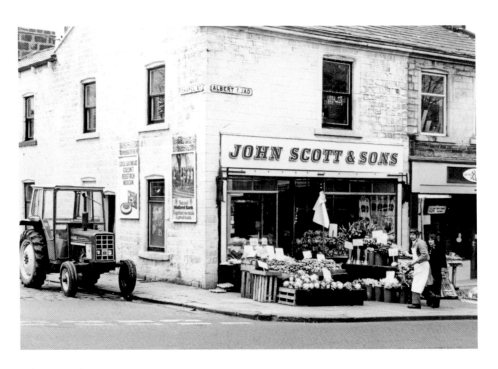

John Scott & Sons

When Colne's first supermarket, Asda, opened in 1971, the writing was on the wall for the hundreds of long-established family-run shops. John Scott & Sons remained open with personal service and quality being the keystone. Founded by John Scott at No. 3 Albert Road before the Second World War, later his sons Brian and Graham would join the business along with assistants Rie Tapscott and Edwin Allen. Brian is seen serving customer Nan Blenkinsop in 1975 and today the business is a discount beer, wines and spirits store.

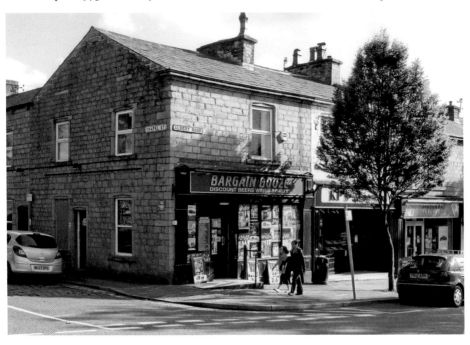

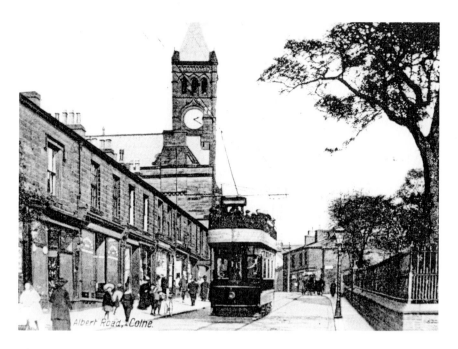

Albert Road, Colne.

The Noble Tram

An excellent Edwardian postcard showing an early tram car trundling along past the row of shops below our town hall. However, the regal trams would last just thirty years in Colne, commencing in November 1903, with the last day of service in January 1934. The fastest speed achieved by the trams was 15 mph whilst going down Primet Hill. The shops below the town hall have seen many well-known local names, which include Leslie Petty, gent's outfitter at No. 6, William Heckford, newsagent at No. 8 and Rennie Goth, tobacconist at No. 10. Today, the affable duo Ann and Paul Ennis have successfully run Rennie Goth's for over thirty years.

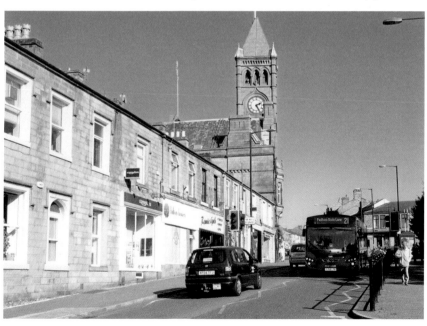

The Kings Head

Now we arrive in Church Street and the stylish 1920s Kings Head Hotel. The original side-entranced King's Head was built in 1790 and named after King George III. In 1924, the ancient hostelry was pulled down and the present-day King's Head was built lower down the row. This is how the hotel looked back in 1968 when I married my dear wife Ruth at our parish church. We both boarded Bracewell's wedding limousine to ride just a few yards to the nearby King's Head for our wedding reception! Today, the hotel has been renamed the Wallace Hartley after our *Titanic* hero.

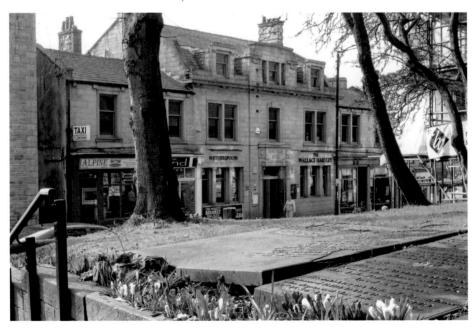

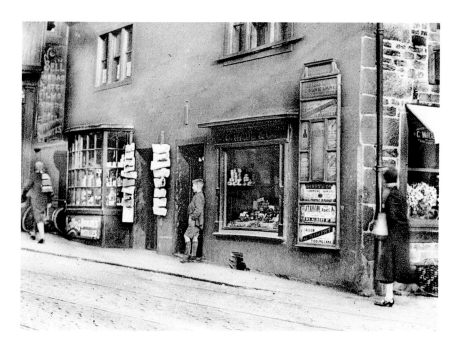

The Last Bow-Fronted Shop

Here at No. 17 Church Street is our very last bow-fronted shop as it looked during the 1920s. This historic 200-year-old building had been virtually unchanged from the 1700s. In the post-war years the ancient shop became a barber's and umbrella maker's run by the genial Cecil Rycroft. Cec gave me my first proper haircut in his old-world shop in the summer of 1947. Tragically, a decade later, when the south side of Church Street was demolished, the bow-fronted building became another of Colne's lost gems. Today, the banking giant Santander and the Duke of Lancaster Hotel occupy the site.

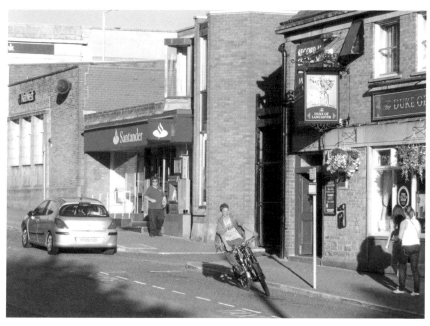

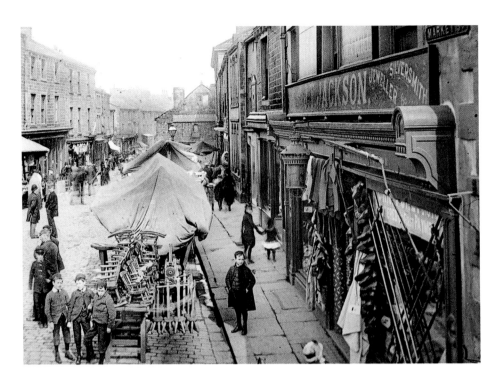

The Street Market

An evocative Victorian street market scene as our walk through Colne arrives in Market Street. The ancient 1611 Dog and Partridge Beer Shop is centre background, while the Hole in the Wall Inn of 1706 is middle right. Note the well-attired Victorian youngsters posing for the cameraman and the sett-stoned main street. These Colne street markets were most popular bringing in many visitors from nearby towns. Today the street markets are long gone, replaced by a steady stream of traffic.

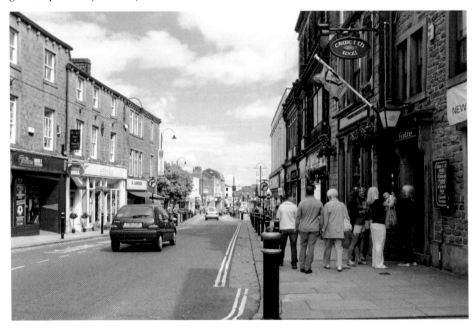

Richmonds Court

Looking from the antiquated Richmonds Court in the early 1970s we can see just how narrow this courtyard was before Ernest Packham's shop on the left was demolished in 1977. Richmonds Court was named after Colne ironmonger Frank Richmond, who had the largest pair of sideburns in Colne. Today, the Altham's travel agents have moved into the Burton's Tailoring Emporium of 1938 and, in the centre of Richmonds Court is a huge eighteenth-century communal grindstone; found when the ancient Market Street buildings were pulled down.

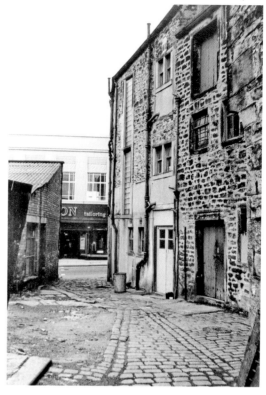

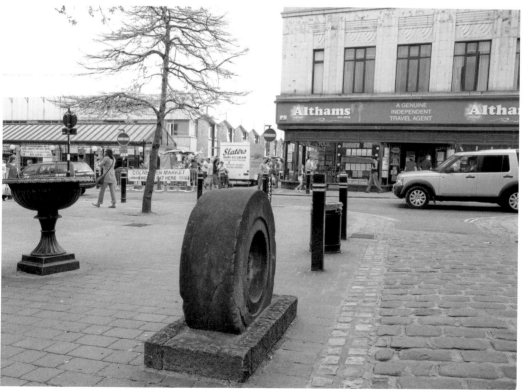

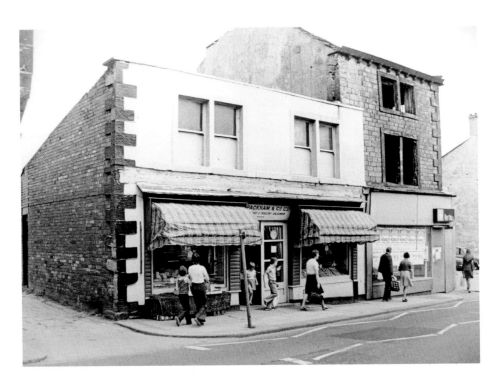

Ernest Packham's

Ernest Packham's was a shop much loved by all Colners and stood at Nos 15 and 17 Market Street from 1932 to 1977. Ernest founded his fish, fruit and poultry business in the 1930s with great success and, on his retirement in the 1950s, the shop was bought by a trio of genial shopkeepers: Harold Cotterill, George Dunn and Jack Hargreaves. Our 1977 picture captures the last days of the store, where today our modern health centre stands.

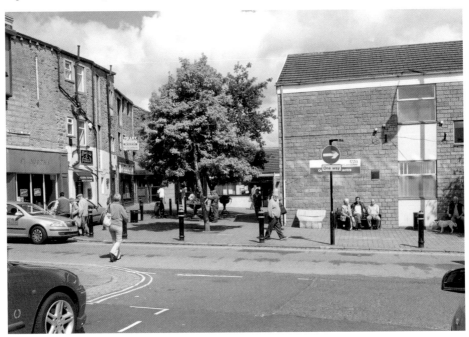

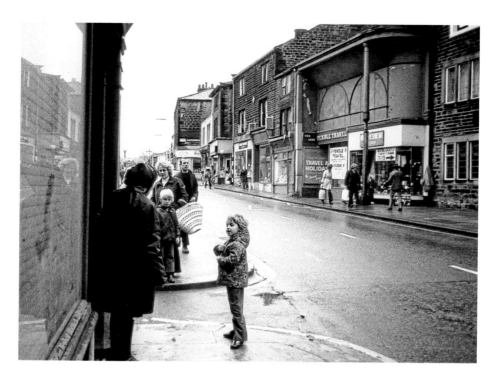

Soon to Go

Here, in our 1975 Market Street scene, are the soon-to-go shops that ran from Richmonds Court on the left to the Red Lion Hotel on the right. These were: Ernest Packham's, North's Cleaners (originally the Bay Horse Inn), Home Supplies run by the likeable Irene and Pat, the Coffee Cave, Terry Wilkinson's butcher's shop, Pendle Travel and the famous Weatherwear shop with the friendly Tina behind the counter. Now, towering trees and our Neoteric health centre have replaced these shops of the past.

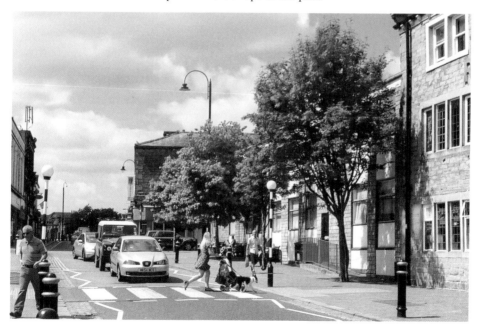

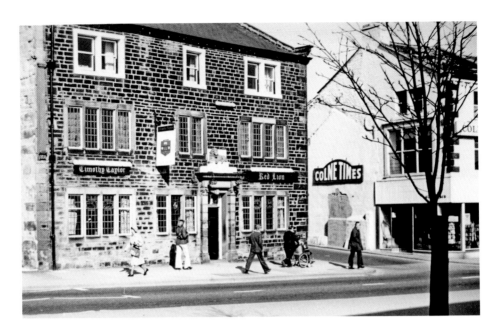

The *Colne Times* Office

Back to 1975 and here, next to the 1962 demolished Dent Square, at No. 33 Market Street, is the *Colne Times* office. Here, on the first floor, worked the elite of local journalism and the legendary editor Noel Wild- a magnificent wordsmith who, in 1973, published my very first feature in the *Colne Times*. Also in the office you'd see the renowned John Jackson, a dear friend whose death at just forty-two was an immense loss to journalism. Tim Proctor, Eric Greenwood, George Embley and Andrew Spencer all plied their admirable trade here. Today the building is a fast food outlet.

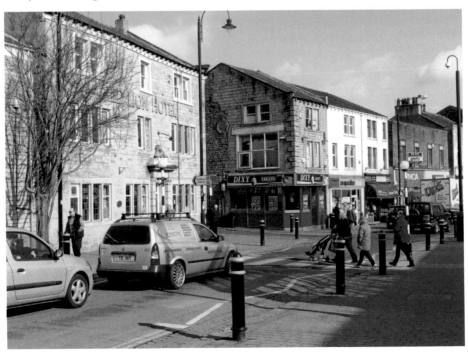

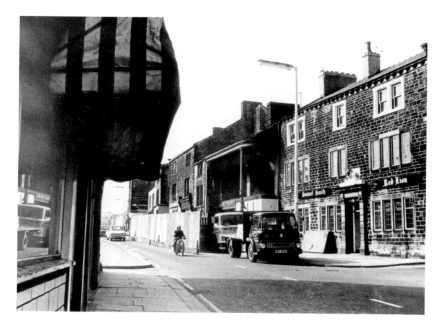

The Red Lion Hotel

The Red Lion Hotel is seen here in 1977 as the adjacent buildings prepare to hit the ground. The Red Lion's name derives from the arms of John of Gaunt, the 4th Duke of Lancaster (1340–99). The present-day Red Lion Hotel was built on the site of the earlier hostelry in 1791 for just £720, and for many years was known as the 'New Red Lion Hotel'. The majestic carved stone red lion was erected above the door in 1904. Today's welcoming hosts are Tony and Joanne Parkinson. Here, outside their eminent Georgian hotel, we see Earby Brass Band leading the Armistice Day parade.

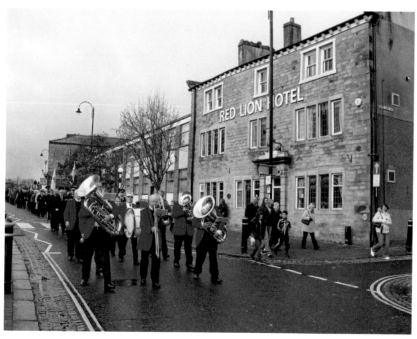

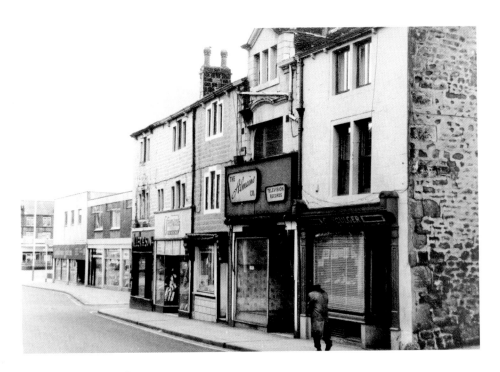

A Well-Remembered Row

Here is a little row of Market Street shops just prior to their 1974 demolition, which were well known to every Colner. From Nos 32 to 40 were butcher Lionel Foulger, Almaine Television and Records, butcher Robert Wilson, Greenwood's men's outfitter's and Miller & Sons carpet dealers. Note just passing the butcher's shop on the right is Lennie the tramp who would walk miles every day, a true gentleman of the road. Today, the site is the venue for Colne's open market, which always has a rich variety of stalls.

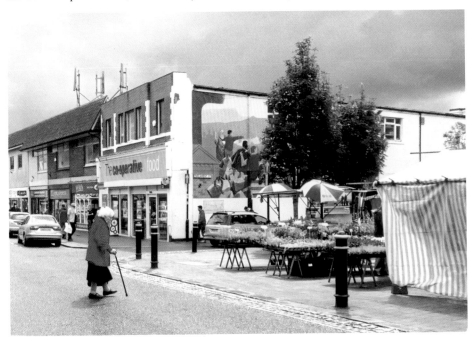

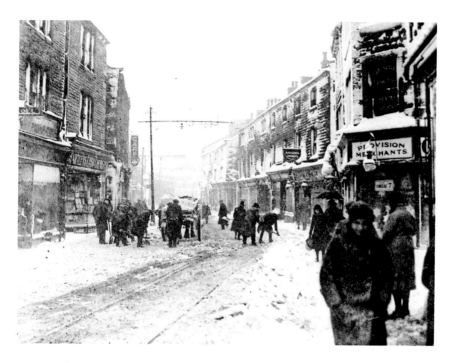

Snow and Summer

A snowy day in Market Street during the 1920s and lots of snow-shifters are on hand complete with the ubiquitous horse and cart. Two of Colne's best-known chemist's of the day can be seen: Hartley's on the left and Taylor's on the right, both now long gone. The provision merchant's on the far right was Gallon's, which would survive until demolition in 1962. Our 2011 summer's day scene shows a busy Market Street with Higgin Chambers to the left. This is to commemorate the nearby Higgin House of 1771 and was bulldozed down in 1933.

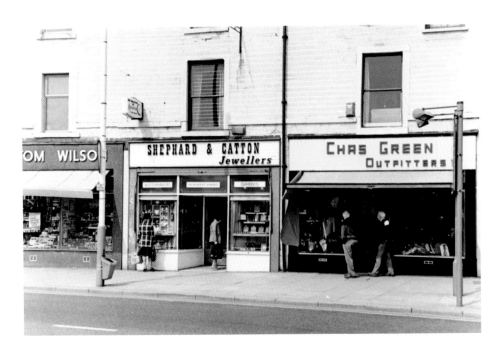

Shops We Knew So Well

This little row of shops next to the Savoy cinema were some of the busiest in our town. Chas Green, the menswear shop, was every bit as trendy in the 1950s and 1960s as London's Carnaby Street. Shephard & Catton, the jeweller's, took over from the reputable Will. E. Halliwell (telephone No. 1) and stocked every make of the prestigious watches of the day. Tom Wilson's newsagent and tobacconist has always been known for value and quality and, as seen in our modern photograph, are happily still trading today.

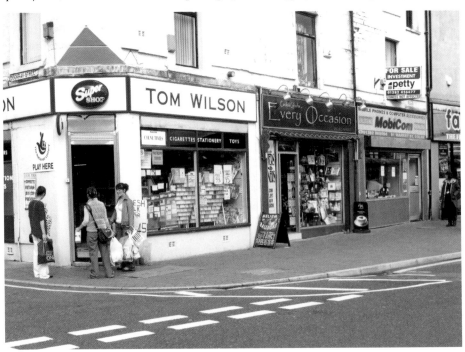

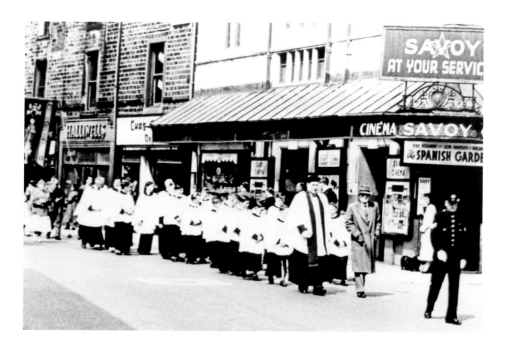

The Savoy Cinema

Here we see our much-missed Savoy cinema in 1956 with the Revd Thomas Dyson MA BD leading the parish church choristers at our annual Whitsuntide procession. The Savoy was a wonderful and imposing cinema with the affable Lew Askew as manager and the legendary Joe Bleasdale shouting out 'less noise!' It was here in 1956 I saw *Rock Around the Clock* with Bill Haley and his Comets. It was truly life changing. Just four years later in 1960, the Savoy closed and soon after that became Scott's supermarket. Today, the frozen food business Farm Foods are trading in the store.

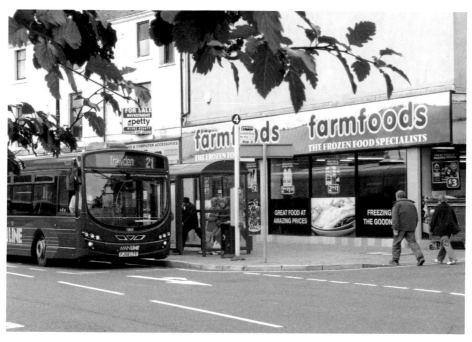

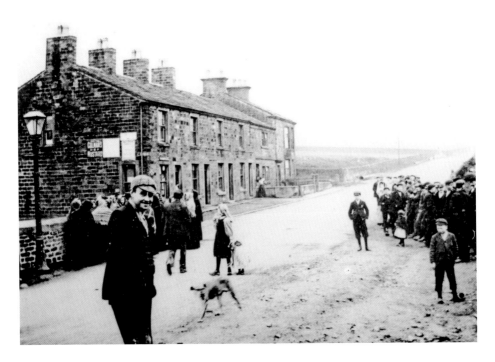

Laneshaw Bridge

Here on the road to Yorkshire we see an Edwardian scene of a group of happy villagers in front of Southfield Terrace, the last terraced row of houses in Laneshaw Bridge. Beyond here, Moorland beckons with Curlews, Lapwings and Skylarks to be seen. Laneshaw Bridge is an idyllic village, which still had its ancient corn mill from the 1700s, although sadly the mighty waterwheel has gone. In the 2011 scene note big changes leading from Southfield Terrace with a huge housing development.

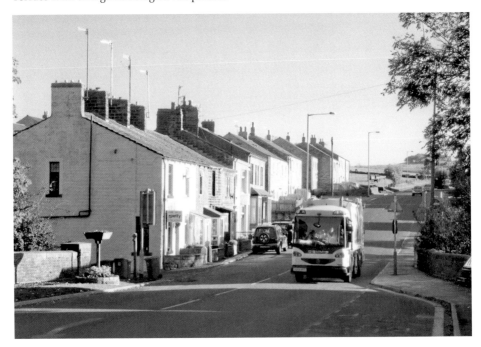

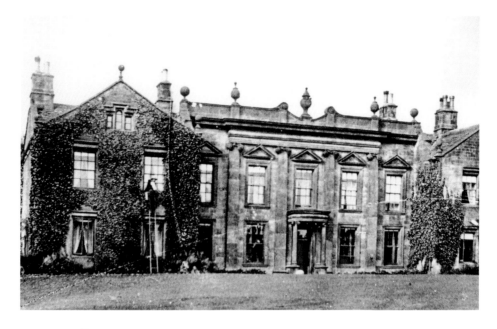

Emmott Hall

The ornate and opulent Emmott Hall is seen here in its splendid heyday. The Laneshaw Bridge mansion house is first mentioned in 1310, then rebuilt in 1693 and modified with its pilastered front in the years 1727 and 1737. When the hall's last occupant, Kathleen Green-Emmott, died in 1939, the once-proud hall began to slowly deteriorate. Partial demolition began in 1956 and, in 1969, a huge pit was dug and 800 tons of masonry from the hall were buried forever. Today, seen here in a stunning picture at Emmott Hall gate piers is local resident Nemone Robinson with her dog Marge.

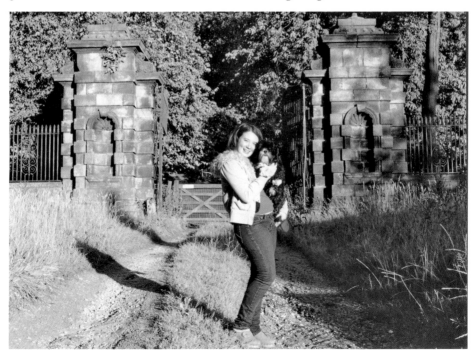

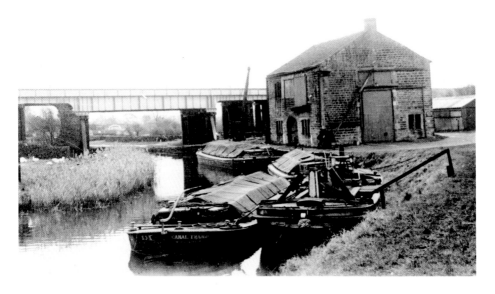

Foulridge

Foulridge, with its meandering canal and stunning countryside vistas, has always been a gem of a village. All along the main approach as you traverse Skipton Road are some of the finest aesthetic houses in the area. Our 1950s scene shows the Foulridge wharf with its old-world warehouse and the mighty railway bridge, which took the weight of thousands of steam engines over the years, speeding to their destinations. Today's tranquil scene shows the bridge, long gone, and the stone warehouse now a busy bistro restaurant.

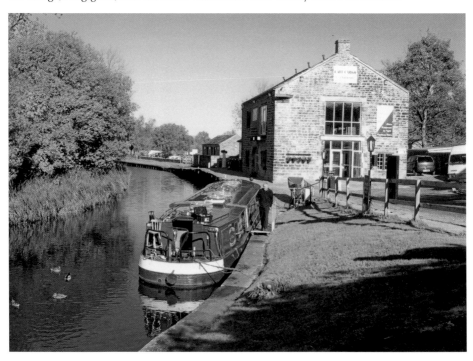

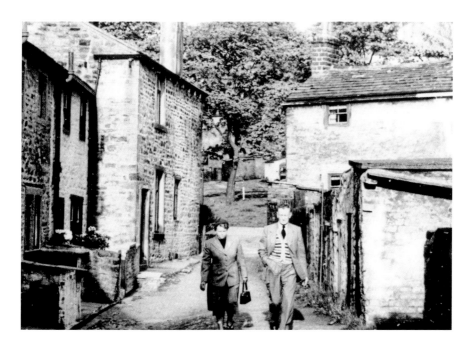

Cromwell Street

Here we see the heart of the village, with almost sixty years separating these two sublime pictures of Cromwell Street. The ancient stone-built houses have an immense charm, and through the gap is the time-honoured village green. The population in the year 1871 was a mere 827, many of these being rural dwellers. Today, due to much housing development the village has become a vastly different place, but its notable Gothic-style church and enchanting Lake Burwain ensure that this captivating suburb of Colne still has a fascinating presence.

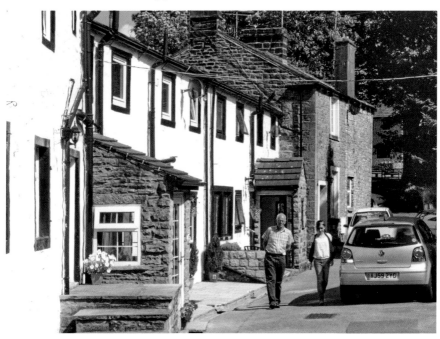

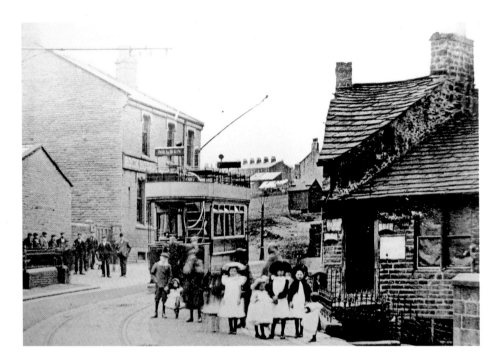

Trawden

Trawden is certainly an ancient and historic place. In the sixteenth century, the very last wolf in Lancashire was reputed to be caught in the then vast Old Trawden Forest. More up-to-date is our Edwardian scene showing the tram to Nelson outside the Rock Hotel. Posing for the cameraman are some most sartorial dressed youngsters of the day. Trawden's population back then was almost 3,000, many working in the cotton mills. Today the mills are no more and the Rock Hotel has been renamed the Trawden Arms.

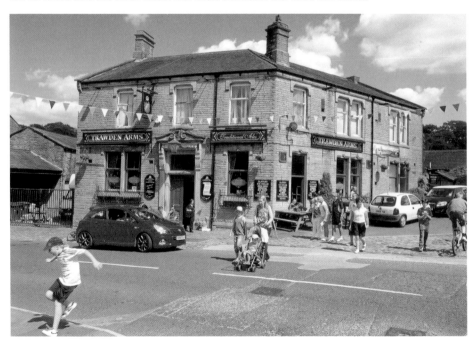

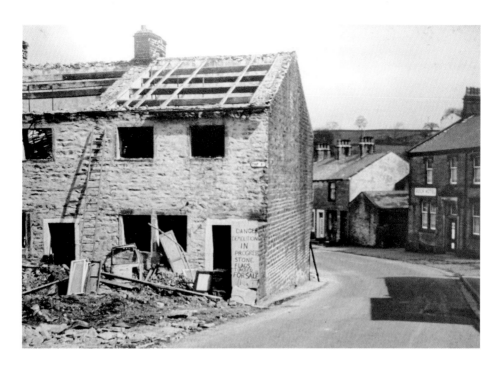

Old Chelsea

This rare photograph captures the final days of a truly historic corner of Old Trawden. Here, in May 1967, is the demolition of an area known as Old Chelsea, with Arthur Wallbank's house at No. 1 Top Street seen here being pulled down. Trawden's eminent historian Stanley Cookson had the foresight to take several photographs of the demolition and also secure the cast-iron nameplates of Chelsea, Top Street and Low Street, which survive to this day. Our colour picture shows Trawden library on the site today with its engaging branch manager, Virginia Grove.

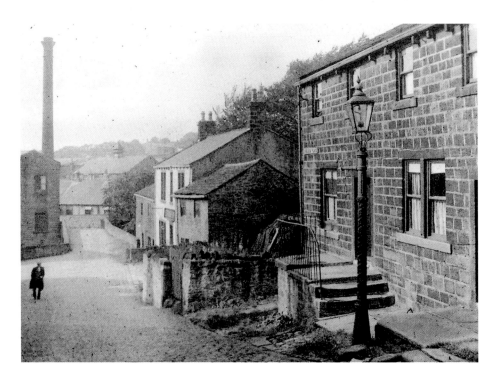

Cottontree and Winewall

Both Cottontree and Winewall villages have an air of nostalgic old-world charm. Here, in the 1950s, we see Winewall Road and the Cottontree Inn (centre right). Old Cobden Place is behind the gas lamp. The long-established Cottontree Inn's best-known landlords were the jovial James Holland during 1940s and 1950s and, more recently, the notable Vincent Day. In our 2011 picture, note the many parked cars compared with the tranquil, traffic-free road back in the post-war years.

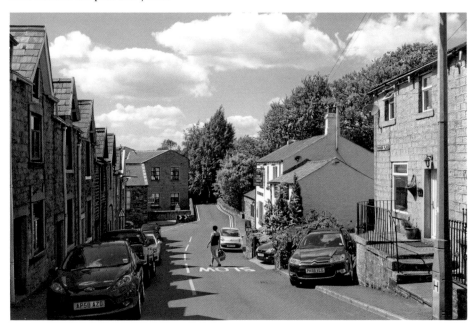

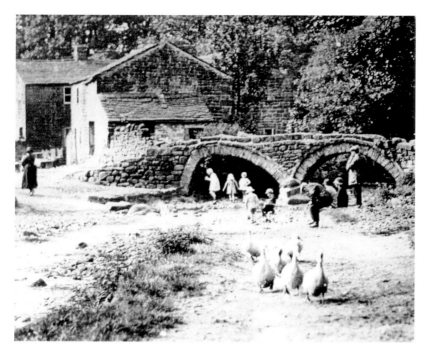

Wycoller

A wonderfully picturesque scene of the hamlet of Wycoller, with its ancient pack-horse bridge centre stage. At one time over 500 people lived in the village. Today there are just a handful, but its charm is timeless. The distinguished historian Ebenezer Folley wrote a marvellous book on the village entitled *Romantic Wycoller* in 1949, and his words back then, just as our two pictures, mean just as much today. 'Wycoller, a place of great beauty and sylvan wonder, where each and every one of us can return to our very own childhood dreams.'

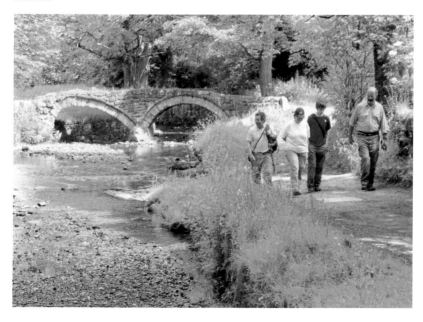

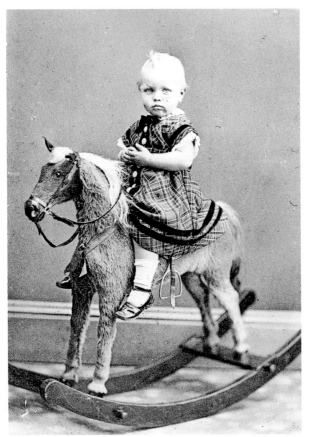

A Farewell to All

As we reach our final page, our farewell pictures show that the joy of being young is timeless. Here, a Victorian girl looks at the camera on her rocking horse just as our twenty-first-century girl – Colin's granddaughter Alice Elizabeth McGowan Bean – smiles out as she plays on her rocking horse. In our book we have endeavoured to show the importance of the continuity of the past for future generations. Our market town of Colne has lost so much, we must heed historian Wilfred Spencer's words in the year 1956: 'We are only trustees for those who come after us.'

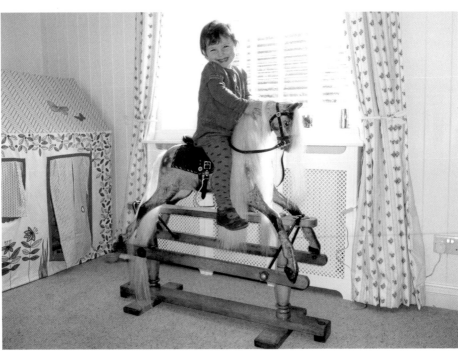